FOOD FOR THE VEGETARIAN

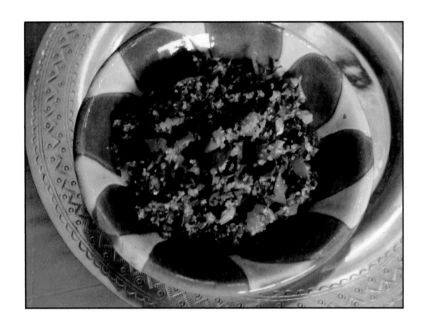

tabbūleh

FOOD FOR THE VEGETARIAN
Traditional Lebanese Recipes

By Aida Karaoglan

INTERLINK BOOKS
An Imprint of Interlink Publishing Group, Inc.
NEW YORK

This revised edition was first published in 1992 by

INTERLINK BOOKS
An imprint of Interlink Publishing Group, Inc.
99 Seventh Avenue, Brooklyn, New York 11215

Originally published by Interlink Books in 1988

Library of Congress Cataloging-in-Publication Data

Karaoglan, Aida.
 Food for the vegetarian.

 Bibliography: p.
 Includes indexes.
 1. Vegetarian cookery. 2. Cookery, Lebanese.
I. Title.
TX837.K255 1988 641.5′636′095692 88-595
ISBN 1-56656-105-1 (pbk.)

Book design and illustration by M. Hamadi
Watercolor on cover by Hazel R. Jarvis
Photography by Aline Gaypara

Printed and bound in Hong Kong

10 9 8 7 6 5 4 3 2

To my husband Roy and my son Marc.

Acknowledgements

All my efforts to complete this book would have stopped short without Azizeh, the genius of our kitchen whose magic hands made the preparation of this book an exciting culinary journey. Azizeh is the perfect example of the traditional Lebanese cook who knows how to produce excellent tasting food without recourse to measurements or recipes. Therefore, I am doubly grateful to her for her cooperation in the constantly taxing effort involved in testing and retesting the results of my research.

My gratitude also goes to Lina Audi, my friend and constant companion on my many field trips around Lebanon. Despite the difficult conditions of war-time Lebanon she helped me overcome my frequent bouts of hesitancy over the usefulness of my efforts in the face of so much tragedy.

A special thank you to Laila Baroody, my long-time friend whose editorial skills and cooperation were highly appreciated.

For general assistance, I am grateful to Gillian Kettaneh for preparing the index, Nicole Andraos, Mona Iskandar, Catherine Kettaneh, Susan Hamza, Janine Maamari and Tarfa Salaam for reading the manuscript and commenting on it and May Halwani for typing the final draft.

To Waddad Salman I say thank you for offering the hospitality of her family in the Chouf, thereby making it possible for me to collect many precious traditional recipes from that region.

I owe a deep debt of gratitude to Josette Saleh, who spent countless hours correcting and editing the French translation of this book and to Claude Edde, who despite her very busy schedule, found the time to correct the first three chapters.

I gratefully extend my thanks to the many people of Lebanon who so generously provided me with information and advice. Those who contributed specific recipes were mentioned in the Recipe Credits at the end of the book.

Finally, it is to my husband Roy and my son Marc that I owe my deepest gratitude for enduring with infinite patience, love and support all the exasperations that the writing of such a book entails.

Contents

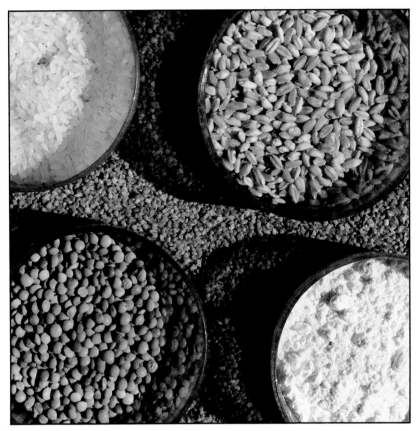

Rice, burghul, lentils, wheat, flour.

Preface

It is hardly necessary, especially nowadays, to emphasize the importance of vegetables and fruits as guardians of good health. This has been recognized by primitive medicine long before anyone had even heard of the science of nutrition.

It is generally believed that agriculture first began in the Fertile Crescent, stretching from the Western Coast of the Mediterranean eastward around the Syrian desert to Iraq. It is held that cultivation was attempted there first because neither climate nor soil was conducive to food gathering. Planting, fertilizing and seed selection became a way of life.

As the Muslim armies swept through Spain in the eighth century, the exposure of the Europeans to the culture of the Arabs must have increased dramatically as the etymology of plant names in the different European languages leads to believe. A lot of vegetables found their way thus into the European kitchen. Many years later, farmers everywhere began to experiment with seed selection to produce new varieties of vegetables and better versions of the existing ones.

Today, the variety of richness of plant life found in the Mediterranean Basin and in Lebanon in particular is proverbial.

This book is intended for those wishing to rely more on plant protein and less on meat protein. It offers the many-faceted traditional cuisine of Lebanon, which is ideally suited to a vegetarian diet. By simply avoiding meat and relying on the wealth of green vegetables, fresh fruits and endless varieties of pulses (or legumes) and herbs, the Lebanese vegetarian is actually relying on his ancestor's recipes and the habits of food in his mountain village. This promotes a natural attitude toward food, not the grim-faced fanaticism of so many vegetarians elsewhere. The Lebanese vegetarian has no need for the gimmicky health foods; just the natural unrefined foods common to his traditional diet. This does not mean that the Lebanese are primarily vegetarian. In fact, the traditional cuisine possesses a rich variety of meat, poultry and fish dishes, which are not included because they are outside the scope of this book. Most of the recipes were collected on the spot in the various villages and towns across the country, from cooks who spent their days between the fields, the pantry and the kitchen. All the ingredients necessary for this diet are readily available in any store or market and those that are not may be found in the speciality shops.

For those who know the recipes by their name in the Lebanese dialect, a full translation with diacritical marks has been provided. It is useful to note, however, that some terms—such as tahini—have made it into the English language.

Introduction

BASIC FOODS

Lebanon's cuisine has been shaped at once by its history, by the diversity of its people, and by the large variety of food available in it. Its cuisine is today at once homogeneous and varied, lavish and thrifty, plain and imaginatively seasoned – a reflection of thousands of years of interaction with Babylonians, Phoenicians, Egyptians, Greeks, Romans, Persians, Byzantines, Turks, and more recently the modern Europeans. All the same, the people of the country have through ensuing generations given their food an unmistakable character very much its own. Its basic ingredients and elements are recognized as such by all Lebanese irrespective of their cultural background or creed.

Bread is the staff of life. It is eaten with every meal and makes up the bulk of the traditional diet. Almost all the people in the towns and cities buy their bread from the local bakery. Some in the remote villages continue to make their bread at home and bake it in the open hearth in their gardens. It can be flat and round with a pocket, or paper thin *(marquq).*

Burghul, also known as bulgar or cracked wheat, is another staple in the diet of the Lebanese. It has a nut-like flavor and is eaten in soups, salads or as a pilaf.

Laban, or **yogurt,** the tangy curdled milk is a necessary item in the home. The Lebanese feel that laban is the supreme health food; it prolongs youth, fortifies the body, confers good looks, and is even good for sunburn. Made generally at home from a starter or culture saved from the previous batch, it is sometimes eaten cold mixed with cucumbers as a salad, or cooked with garlic and mint with rice on the side, or diluted with water and salted as a summer drink. Drained of its liquid in a piece of cheesecloth, it becomes a delicious cream cheese called *labneh.*

Olives are also a standby in the Lebanese household. They are native to the country and have enjoyed a respected place since ancient times. They are treated in various ways: pickled in water, vinegar and oil; slit and marinated in garlic, chili, lemon and oil, or dry-salted in wicker baskets.

Oil pressed from the olives is used so often that a year's supply is frequently bought in advance. Home pressing still takes place in some villages. The resulting oil, because it is cold pressed, is low in cholesterol and is often recommended by health food advocates. Nowadays, however, most of the olive oil produced is processed commercially in power-mills.

Pulses or **legumes** are as old and as basic as olives. In Lebanon they rank just behind bread in popularity. Rich in protein, pulses like beans, lentils and peas are served cold as salads, hot in stews and thick soups. Chickpeas are blended with sesame paste *(tahini),* garlic and lemon to make perhaps the most popular of all Lebanese dishes, *hummus.*

Rice, which is another staple is often served plain, cooked in butter and salted water on the side of the various vegetable stews, or as a pilaf with herbs and vegetables, garnished with almonds, pine nuts and unsalted pistachios.

Long-grain rice is preferred for all pilafs, but short-grain rice is preferred for stuffings.

It is quite obvious to the newcomer to Lebanon that its food gains much from **spices.** For centuries this region has served as a funnel for the spice trade from the East to Europe. Most of the spices widely used in Europe, and some more exotic known only in Asia, are available in Lebanon and in the rest of the Middle East. The Lebanese, however, favor seasonings that are grown at home such as cumin, coriander, native saffron, red pepper and sumac.

The Lebanese have always laid great store by the wealth that nature has provided them with in the form of plants and herbs, fresh fruits and vegetables. The climatic variations in the country have contributed toward making the plant life extraordinarily rich and varied. Rain falls from October to April. Winters are temperate averaging from 40°–50° during the coldest months. Spring is early with the flowering period in some areas as early as February. It rises to its peak in April when a rich variety of annual plants cover the plains and hillsides. By summer, only the thistles and a variety of mints remain in flower. The summer months are hot over most of the coastal region – over 70°. They are ideal months for ripening the fruits for which Lebanon is justly famous. In addition the farmers have in the past imported many subtropical plants to grow in gardens and orchards. These include loquats, guavas, cacti, avocados, custard apples, all of which were foreign to the ancient Lebanese. Today they are considered an everyday

item in the marketplace.

The **herb garden** of the early Lebanese supplied the household not only with the herbs for flavoring their dishes, but with cough mixtures, tonics, sweet waters, love potions, insecticides and cosmetics. Today, **lavender bags, herbal teas, medicinal valerian, vervain** and **spearmint** still have their enthusiasts. A number of tisanes and essences have survived from these ancient times. **Jasmine, saffron, mace, rose, chamomile, anise** and **bitter orange blossom** are also brewed into teas and drunk.

The present **fresh fruit** and **vegetable** industry is vital and constantly changing in response to the needs of the marketplace. It varies from the home gardens in the mountains, to large farming companies, to family farms in the plains and coastal areas. The produce is always available in stores and supermarkets and through the ambulant vendors, at prices the average consumer can readily pay.

A much favored vegetable is the **eggplant,** which is also one of the most versatile. It boasts a profusion of recipes: It is grilled or roasted, peeled, sliced and fried, stuffed with rice and vegetables and cooked, or stuffed with walnuts and pickled. As a preserve, the eggplant is a true delicacy.

Green beans, crisp and long, tender, flat and round, can be found all year round. The **broad bean** or **fava bean,** the round velvety podded variety, is held in high esteem. All these are used in salads or as stews with rice on the side. Some are pickled with salt and vinegar.

Cabbage and its descendant the **cauliflower** are also familiar sights in the market stalls. The white cabbage variety is the most commonly used although both green and red cabbage are familiar sights. Cabbage leaves are sometimes served as an accompaniment to the national salad, *tabbūleh.* It may also be served in soups, or stuffed with rice and herbs.

Zucchini are widely grown and available all year round. They are cylindrical and straight, with a light green color. They are prepared much like eggplant. Their pulp is served in pancakes, omelettes and casseroles.

Tomatoes, lettuce (romain, iceberg and butter leaf varieties), **cucumbers, spring onions, flat parsley** and **fresh mint,** are used in salads and stews and as garnishings. In more recent years, **asparagus, Brussels sprouts, broccoli, celery, endives** and **mushrooms** have made their appearance in a regular manner in the city supermarkets. However, they are still considered foreign to the traditional cuisine.

Other vegetables that can be found are **artichokes, taro, beets,** and **carrots.** Artichokes were known for thousands of years in the Mediterranean and are generally served stuffed with carrots, onions and peas, or boiled and sprinkled with a lemon dressing. **Taro** is a large and starchy tuber and is very similar in its nutritious value to the potato. It is easy to grow and must always be served cooked since it is toxic if served raw. **Beets** are boiled and added to salads with a variety of dressings, or to pickles as coloring. **Carrots** are small, well formed and smooth and are eaten raw, pickled or cooked.

The wild leafy plants, **spinach, dandelion greens, watercress** and **Swiss chard** turn up almost everywhere in spring. They taste good and are considered agents of good health. The Lebanese have a variety of ways of preparing them: as salads, or stuffed and cooked in olive oil, or as stuffing for pastry.

No home is ever empty of a basket of **fresh fruit.** Fruits are served at any time of the day, more often after meals in place of dessert. Favorite fruits have always been **figs** and **grapes. Figs** are eaten fresh, made into preserves or jams and dried and stored for winter to be eaten with walnuts as snacks. **Grapes** are eaten fresh or dried as raisins. They are also used to make molasses, the local spirit **arak** and the excellent Lebanese wines.

All fruits grown in temperate climates and some that are semitropical can be found in the supermarkets of Beirut. **Oranges, lemons, grapefruit** and their varieties, **melons, apples, pears, peaches, berries, plums, apricots, dates** and **pomegranates** are among the many to be seen in season and some for the greater part of the year. When fresh fruits are less abundant, and therefore more expensive, **jams, preserves,** and **stewed** or **macerated** dried fruit begin to appear on the dining table.

Large quantities of **pastries** and **desserts** based on various kinds of flour, honey, nuts and preserved fruit are consumed by the Lebanese. Many of the pastries are sold in specialty shops but they are often made at home especially for holidays or on festive social occasions like weddings or births.

Nuts play an important role in the traditional Lebanese diet. The oils they release when heated add a delicious nutty flavor to pilafs and desserts. The **almond tree,** whose white blossoms often appear in the spring before the last snows have melted, is one of the most familiar sights in the countryside. The tree provides the tender fruit, which is often eaten green. When the almonds are dried or

roasted and pulverized, they are used to make sauces and oils that are then added to the main dishes and desserts. **Hazelnuts** are wonderful nuts that are more easily digestible than almonds though much less frequently used in cooking. **Walnuts** are also eaten green or dried, ground and used in sauces and desserts. It is the **pine nut,** however, that is the true standby. Small and handy, pine nuts add a delicate seasoning contrast to vegetables and sweets. **Pistachios** are used for their decorative green color as well as for their pungent flavor.

No meal ends without **coffee.** The best coffee is brewed from fresh-roasted and ground coffee beans. The beans are usually roasted until just brown, never blackened, to prevent any bitterness. Coffee beans are traditionally ground in the mortar with a pestle or more frequently in a special brass handgrinder.

Today, however, coffee is more likely to be bought already ground from the coffee vendor. Sometimes ground cardamom is added to coffee before brewing it to give it a special flavor. Good coffee drinking requires that it be brewed fresh just before serving, never warmed up.

To become familiar with the basic food of Lebanon is to begin to understand the main character of its people. The activities of preparing and cooking nature's bounty is an intuitive art for the Lebanese, not precise or progressive. It is an activity that is basically reflecting a social way of life. It reflects above all, a passion for pleasure and an unwavering attachment to the slow natural rhythms of leisure.

Part One

THE PANTRY

All the methods of food preservation in the rural Lebanese home are deeply traditional, an inherited art ingeniously suited to the surroundings. A good part of the Lebanese population still lives in a village society with an unshakable attachment to nature and land, and takes pride in being self-sufficient. The women in this society have a good share of the workload. The dry season or summer is the busiest time of the year, for it is then that work begins in the gardens, vineyards and orchards. August is the time of grain harvest. During the busy weeks of reaping and threshing, all village hands, including the women, work in the fields. When the crops are brought in, the women set about preserving the food for the long winter months.

Preservation methods have been known for centuries and remain basically unchanged. Food is dried, pickled and spiced. The flat rooftops of the homes are transformed into areas where peas, beans and chickpeas are sorted and dried on large straw trays. Figs and apricots are laid out in the sun in anticipation of the jams and preserves. Grapes are harvested and dried as raisins, crushed for molasses, made into wines, or distilled into *arak,* the local spirit. Food is finally sealed in bins and jars, which are then stood on the dark cool shelves of the pantry. Strings of onions, garlic, chili peppers and okra decorate the pantry ceilings.

The city dwellers, on the other hand, have the restricted accommodations of city apartment houses to contend with. A complete pantry is hardly feasible. But all the same, no home is without its jars of pickles and preserves, or its containers of dried legumes, herbs and spices. The supplies are either bought from a source in a mountain village or more often from the neighborhood market or store.

Bread

Historically, the predominance of wheat in Lebanese agriculture is one of its striking features. Bread has been a household commodity as far back as the Middle Ages, when in Europe only the upper classes were aware of it. Wheat flour is the ingredient used to make bread. Wheat grown in Lebanon has a hard grain and is high in gluten content. It is the gluten or protein in the flour that gives the elasticity to the dough, which makes for better bread. The rural housewife bakes a week's supply, which she stores wrapped in cloth and placed in large earthenware or straw containers in the pantry.

When baking bread at home, it is worthwhile to prepare a large quantity to be frozen and used later. Place the bread in sealed plastic bags. Heat when needed, wrapped in foil in a hot oven.

Flat Bread

khubz'arabī

6 cups flour
2 teaspoons dried yeast
2 cups warm water
1 teaspoon salt
½ teaspoon sugar

Dissolve the yeast in ½ cup warm water. Add the sugar and set aside. Sift the flour and salt into a warmed mixing bowl. Make a hole in the center and pour in the dissolved yeast. Add the water gradually while kneading until the dough is smooth and elastic, about 10 minutes.

Oil a bowl and put the dough in it. Cover with a cloth and set aside for 2 hours to rise. It should double in size. Turn out the dough on a lightly floured board and punch it down. Knead for a minute and divide it into 6 equal parts. Roll each piece into a 12-inch round and place it on a lightly floured cloth. Cover and set aside for 30 minutes. Place oiled baking sheets in the oven for 20 minutes to heat them thoroughly. Slip the dough rounds on to the trays and bake for 8 minutes. The bread puffs up like a balloon, creating a pocket in the middle.

Cool the bread on wire racks and store in the refrigerator.

Bread Sheets

khubz marqūq

The dough is prepared as in the master recipe for flat bread. Each round of dough is then stretched and flipped from one arm to the other until it is paper thin. It is then flipped on to a round cushion and stretched further. The art of shaping the bread is mastered after much practice and is passed on from mother to daughter. It is then baked on a thin metal dome called a *saj* that is preheated over a fire until it is very hot. The bread sheets require only 3 minutes to brown. The bread sheet is peeled off and wrapped in cloth to keep it fresh and soft.

Cracked Wheat

Burghul

To prepare *burghul*, also sold as bulgar, the peasant woman hulls, sifts and washes the wheat to remove impurities. She then fills a large iron cauldron with water, brings it to the boil and drops in the hulled wheat. She boils the wheat until it is partly cooked, or merely poached. She then removes it to a large straw tray to dry in the sun on the rooftop of her house. Once again she picks out all the remaining stones and other impurities left among the grains. It is now ready to be ground, either at home on a traditional stone hand-mill that differs little from the mills dating back to 1,000 B.C., or in the commercial power-mill. In either case, the wheat is dampened first and then ground in grades: **coarse** used in pilaf, **medium** for fillings and **fine** used in salads. The very fine flour-like remnant or *srīra* is rarely available commercially but in the home it is used to make *swayq*. See recipe page 123.

Burghul, fermented with laban in a lengthy process, is called *kishk*. It is a standard item in the rural pantry.

Kishk

5 pounds coarse burghul
30 pounds laban (yogurt)
2 pounds coarse unrefined salt
8 cups whole milk

Soak the burghul in the laban and set aside covered for 8 days.

Uncover and rub between the palms adding the milk. Set aside for 8 more days until it ferments.

Form small individual balls and place them on a large cloth sheet in the sun for 3 days.

Finally, when the mixture is dry and hard, grind it using a portable rotary grinder. Store it away for use in soups during the winters.

Kishk may also be found ready-made in Middle Eastern stores.

Olive Oil

Samneh

The favored fats in Lebanese cooking are olive oil and *samneh.* The oil is extracted by pressing in hand-operated pressing machines or in commercial power-mills. The first yielding provides the finest oil, which is greenish in color. This quality keeps longest. More oil is extracted subsequently of lesser quality. Olive oil when pure and unadulterated contains 60% fat. It is rich in potassium, which makes it a good cleansing and healing agent. Scientific tests have proven that, since it is unsaturated, it will not raise the blood cholesterol. It is considered in Lebanon as a mild and effective laxative and a tonic for the gallbladder. It is sometimes used to remove foreign particles from eyes and ears. The Lebanese store it in large blown-glass bottles or large glazed earthenware jars.

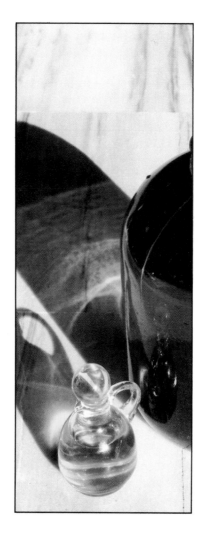

This is pure butter fat, which imparts a special flavor to foods. It can be heated to a high temperature without burning. It is made from sheep's milk that is clarified to remove all water and impurities. To clarify butter at home, melt unsalted butter in a pan, and when it begins to foam, skim off the foam and pour the clear oil into a container through a sieve covered with a piece of cheesecloth. Cool, seal and store.

Spices and Flavorings

As far as we know, spices have always been with us. The ancient Lebanese knew and used spices as we do today: in food and drink, in perfumes and as preservatives. The edible plants containing aromatic oils have been called the hidden soul of cooking. The Lebanese favor such seasonings as white and black pepper, cinnamon, cardamom, cloves, nutmeg and a spice blend called *bhar*, which is a combination of cinnamon, nutmeg and cloves. It is very similar to allspice, the fruit of a tropical American tree of the myrtle family.

For the best results, the spices are stored whole, ground with a pestle in a mortar when needed. Whole spices are much more full-flavored than containers of ground spices that sit for months on the shelf.

Buy your spices from a reliable dealer who supplies them rich in color and fresh and strong in aroma. Store in a dry airy space. Heat and dampness rob them of their flavor. Since spices give up their flavors more quickly when ground, add them near the end of the cooking time; a good time is always with the salt.

Cardamom is a member of the ginger family, native to India. It is sometimes used mixed with ground coffee beans to add a special flavor to the traditional Arabic coffee. See recipe page 152.

Black Cumin is a small black seed used in bread, cakes, and to flavor *hallūm* cheese. See recipe page 44.

Cinnamon is a native to Ceylon and Mexico, and is possibly the first spice known to man. It is taken from the bark of the cinnamon tree and is the most fragrant of spices. In a complicated system of rotation and pruning, the bark is peeled from the tree, rolled into quills, dried and shipped. The Lebanese cook always keeps it on hand as a very essential spice. It is used in almost every dish: alone in desserts and cakes, and in combination with other spices in main dishes.

Cloves are native to the Moluccas or Spice Islands. As a seasoning, cloves add wonder to the flavor of long-cooking dishes. Cloves are preservatives when added to the cooking of fruits such as figs and dates. They also constitute part of the bhar blend.

Mahlab is a Syrian spice produced from the kernel of the black cherry pit. It has a sweet fragrance and is used to flavor breads and sweets.

Mistki, the resin from an evergreen tree, is used as a chewing gum to sweeten the breath. When ground into a powder it is added to ice creams and desserts.

Nutmeg is from a tropical island tree that grows near the sea. It is a charming seductive spice that is an essential part of the spice blend bhar so frequently used in Lebanese food.

Pepper is native to India and perhaps the world's most desired spice. It is a perennial vine with clusters of berries that look like currants. Black and white come from the same berry. The young berry is black while the mature berry is white and milder as the outer husk is removed. Pepper is essential to all long-cooking dishes and marinades.

Sahlab is a cream-colored powder from the dried tubers of the wild orchis. It is made into ice cream and a hot drink sprinkled with cinnamon.

Turmeric, which has been used as a dye for centuries, is used for brilliant yellow and orange color. The Lebanese use it to color and flavor certain desserts such as *sfūf* and *mfatta'a*.

Sesame, the pale cream seed of a plant grown in tropical regions, is basic to Lebanese cooking. Sprinkled on bread, rolls or cookies, caramelized, or toasted and made into a paste, it is invaluable to the Lebanese cook.

Tahini is the paste made from toasted sesame seeds. Store the cans unopened upside down to keep the tahini from separating. It may require blending before using.

Herbs

The use of herbs in Lebanon, particularly in cooking, has never ceased. Herbs were part of the daily life of the ancestors of the Lebanese and have been handed down to form a great tradition. They had once been medicine, mythology, food, flavoring, drinks and garnishings. Today's rural housewife still weeds her own beds and gathers the herbs. She adds herbs to her cooking or makes them into vinegars, potpourri and perfume sachets to keep her linens sweet. Her faith in the healing powers of these young herbs, taken in the form of broths and infusions, has remained constant.

To enjoy the homegrown herbs all year round, the herbs are dried. The aim is to preserve most of the natural colors and all of the natural oils that give them their flavor. The herbs are gathered in the morning after the sun has dried the dew off the leaves and before it has become too hot. The simplest and most natural way to preserve the herbs is to hang them tied in bunches in a dry shady place or over the stove in a well-aired kitchen. Sometimes a wooden rack or sieve covered with a thin muslin or net is used, and the leaves are spread thinly on the cloth. They are left in a dry cool place and turned daily to dry evenly. When they have become crisp but not brown, they are stripped from the stems and placed in airtight jars in a dark cupboard. The

process takes about 6 days. Herbs can be picked and dried throughout their growing season, but thyme, marjoram and oregano are best dried when in bloom. The blossoms have even more flavor than the leaves. Some herbs are not suited to drying, such as parsley; it is best used fresh and is used in abundance by the Lebanese cook. Basil, mint, sage, wild fennel, rosemary and marjoram retain their natural flavors when dried. **Seeds** store even better than leaves. They are usually dried in the sun for 2 hours after being removed from the seed head then placed in paper bags in a dry place for two weeks before being stored.

Herbs used in cooking

Bay Leaves – Bay is a native of the Mediterranean area. The leaves have an affinity with a variety of foods. Often used in soups, sauces and casseroles, they are good with almost any vegetable. To dry bay leaves, pick them individually and leave them in a cool, airy, shaded place for a few days, and then pack them into airtight jars.

Coriander – Only the fragrant seeds are dried. The leaves are eaten fresh and are prominent in Lebanese cooking. Along with olive oil and garlic, coriander livens up almost every vegetable and legume dish.

To preserve coriander seeds, cut off the heads and dry them in an airy room on racks or in a container lined with muslin or in paper bags. When the seeds are quite dry, shake them out and store in airtight jars. Keep one month before using to improve the flavor.

Fennel – It is a vigorous perennial. A native of Lebanon, it grows wild in coastal areas. The strongest flavor is in the seed, which is pounded or used whole in cooking. The leaves, stems and seeds dry well. The leaves and stems should be picked when they are young and hung in bunches away from strong sunlight. When dry, they are crumbled into airtight jars. For the seed, cut off the flowers and stems before the ripe seeds drop and hang in paper

bags in a dry place. Store when dried in airtight jars.

Garlic – The distinctive smell and taste of garlic make it one of the favorite flavorings of the Lebanese cook. Its uses are infinite for all kinds of savory preparations. Apart from its wonders in cooking, garlic has been for a long time thought to clear the blood, and when rubbed raw on a bee sting, to remove the poison and reduce the inflammation.

To preserve garlic, the bulb should be lifted off when the leaf tops turn brown and dry. The bulbs are then spread in the sun in a dry airy place to ripen. They are then stored in a cool dry place on racks in bunches, or made into ropes.

Marjoram – It is native to Asia. The variety that grows in Lebanon is the wild marjoram. It has distinct preservative qualities. It is a most versatile herb with a sweet spicy flavor. Its fresh leaves are used in omelettes and with vegetables. Dried, it is delicious sprinkled on a zucchini salad. Cutting time is vital in the drying of marjoram.

Cut the stems just before the green buds bloom. For the full flavors, cut in the early morning after the dew has dried and place on racks, or tied in bundles in an airy cupboard. When quite dry, crumble into airtight jars and store.

Mint – The variety of mint most commonly used in Lebanon is spearmint. It is used in generous amounts in salads and sauces. The Lebanese retain the comfortable habit of a soothing cup of mint tea to aid digestion. Mint leaves dry well.

Pick fresh young leaves and hang them in bunches in a warm place away from strong sunlight. When quite dry, place them in airtight jars and store them.

Sage – It is one of the old favorites for its healing properties. Many rural people believe it cures all sorts of diseases and afflictions. It grows wild in full sun and in well-drained soil.

To dry the leaves, pick them in spring, before the flower buds form. Hang in a dry place away from sunlight. Use to make an infusion and drink it hot as a tonic.

Thyme – There are several varieties of thyme. The most commonly used in Lebanon are common thyme and lemon thyme. They are shrubby evergreens familiar on stony coasts and mountains. Thyme is eaten fresh or in salads or dried and mixed with sesame seeds and sumac and spread on bread and baked.

Cut the sprigs when the plant is in bloom, hang in a shady airy place for a few weeks, then store in airtight jars. Use to make *za'tar*.

Za'tar
2 cups crushed dried thyme
1 cup sumac
½ cup sesame seeds
1 tablespoon salt
Mix well and store in jars. Mix with olive oil and serve with flat bread.

Sumac – The berries of the sumac tree are dried in bunches away from sunlight and crushed to make the powder that is used in many Lebanese dishes.

Herbs for Tisanes, Sachets and Potpourri

Anise – The aromatic fruits of the small annual plant contain the oil-bearing aniseed, which is used in the making of *arak* the local spirit and in the flavoring of breads and cakes. Aniseed tea is said to remedy diarrhea and to soothe indigestion.

Gather the seed heads in early autumn and dry them away from sunlight in paper bags or on racks.

Chamomile – It is a slow-growing annual with small white daisy-like flowers that have a lovely perfume.

Pick the flowers for drying when the flower petals drop back from the bud. Dry the flower buds away from sunlight in bunches, and use in hot infusions for digestive disorders. It is also well known as an herbal rinse for blond hair.

Lemon Balm – The dried leaves of balm are taken as a refreshing tea that has a mild sedative effect. Lay the branches on the floor to freshen the room, or fill into bags or sachets for the linen closet.

Orange Blossom Water – The blossoms of the bitter orange tree are dried away from sunlight and distilled to make orange blossom water or essence. It may be drunk as a hot infusion (referred to as white coffee) or added to foods and desserts as a flavoring.

Rose – The eglantine rose petals when properly dried will give color and fragrance to desserts and potpourri. The distilled essence of rose petals or rose water, is essential to Lebanese desserts. Diluted in hot or cold water, it makes a refreshing drink.

Drying Fruits and Vegetables

Lavender – It is a small perennial shrub that is mainly used as a perfume and in sachets. Both flowers and leaves are dried in herb cushions and potpourri. They are known to keep away moths, and sweeten the air of the linen closet.

Tisane – The actual preparation of tisane is much the same as making ordinary tea, and like ordinary tea, it may be drunk on its own or with a slice of lemon, honey or sugar.

Allow one level teaspoon of dried herbs to one tea cup. Pour in boiling water, cover and let stand for 3-5 minutes to infuse, then strain. Teas made from seeds are prepared in the same way. However, the seeds should be crushed in a mortar before being used.

Potpourri – Making potpourri is an old but still popular method of preserving the perfume of flowers and leaves. They are made from flowers, fruits, herbs, barks and spices.

Place the dried hips of the damask rose in airtight containers with a handful of salt for a week. You may wish to add flowers such as carnations, jasmine, orange blossom and sweet peas as well as the leaves of lavender, bay, sage, basil, thyme, balm and rose geranium. Any combination of the above will sweeten the air in your home.

Today in Lebanon drying fruits and vegetables still takes place in the sun, on the rooftops of houses or the balconies of apartments. Fruits such as figs, dates, grapes and apricots, and vegetables like okra, chili peppers, peas and mushrooms are all dried by the sun. When space is not available, the home oven is used for drying. The two main requirements for drying at home are correct and steady temperatures.

Use perforated trays on which to lay the vegetables; air must circulate through them. Set your oven on very low and leave the door slightly ajar. The correct temperature should be between 50°-150°. When the drying process is completed, remove the trays and allow to cool at room temperature for one day. Pack in greaseproof cardboard or wooden boxes. Use greaseproof paper to line the box. Never pack in airtight containers and always keep in a cool and very dry place.

Once properly dried, fruits and vegetables will keep for many months. Before using dried fruits, soak them overnight, then gently simmer until tender.

Beans, Lentils and Peas

Of all the foods available today, perhaps the most nutritious are legumes. Loved by all, rich and poor, their use in the Lebanese diet ranges from soups and starters, to main courses, breads and desserts. Pick them when the pods have become yellow, then shuck them and dry the seed. Slow drying gives the best results. Warm air and ventilation are all that is required. In rural Lebanon legumes go through a series of threshing and sifting and sorting to remove grit and pieces of dirt, which takes place in the sun on the rooftops of the houses. Dried beans, lentils and peas can be stored for relatively long periods, provided they are stored correctly in plastic or glass containers with tight-fitting lids in cool dry places. They must not absorb water to keep from spoiling, nor must they lose too much moisture and become too dry to cook. Soak all legumes except lentils and black-eyed peas for 10-12 hours before using them. Beans will cook in 1-2 hours depending on the type.

Olives

Olives are of the oldest cultivated crop indigenous to the Mediterranean. Methods of preserving them have changed little over the centuries. The fresh fruit is bitter and must be treated before it is edible. Otherwise, preserving olives is a simple matter. They are mostly placed immersed in brine in earthenware jars and covered and left in a cool dark place.

September Olives are bitter and must be bruised with a wooden mallet and soaked in water for 10 days. The water is changed daily until all bitterness is removed. The olives are then kept in brine, and should last for five months. Prepared in this manner, they may be eaten one week later.

November Olives or ripe olives are the greenish black variety. They are cured by being bruised with a wooden mallet, soaked for 10 days in water, which is changed daily, and left steeped in brine for one week before being used.

December to February Olives, because they are picked late, will have lost almost all their bitterness. They are simply layered with salt in straw baskets for one week to drain. They are then covered with oil and consumed within a few months.

Brine
To every 4½ cups water, add ½ cup coarse rock or sea salt. Herbs and spices such as coriander, garlic, cloves, bay leaves, chili pepper and thyme are sometimes added to give flavor.
Bring the brine to the boil. Cool and pour over the olives in sterilized jars.
Sterilizing jars – To sterilize the jar, wash it well in soap and hot water, rinse well and drain. Stand the jar upright in a cold oven. Heat the oven to 300°. Turn off the oven and cool the jars in it. Remove when required for filling.

Winter Olives

zaytūn kfarḥūna

6 pounds green olives
1 cup vinegar
10 cups water
enough coarse rock salt to float an egg
 (see **Brine** *recipe)*
1 tablespoon citric acid
1 teaspoon cloves
2 green chili peppers
1 small olive branch

Bruise the olives with a wooden pestle and place them in sterilized jars. Dissolve enough salt in water to float an egg. Add the vinegar, cloves, citric acid and pepper and pour the marinade over the olives. Top with the olive branch and seal. The olives will be ready to eat 2 months later.

23

Pickling Vegetables

Pickles

The Lebanese have always preferred eating their vegetables fresh and in season. But the early Lebanese who grew vegetables had been tied to the seasonal cycles in which the plenty of spring and summer was followed by the more meager produce of winter. It is no wonder that they developed traditions of pickling, drying, salting and bottling for the fruits and vegetables in season. With the advent of greenhouses and easy transportation, it has become possible to buy almost any kind of vegetable anywhere at any time of the year. Consequently, the old and tried methods of preserving food have suffered a decline, especially in the cities. All the same, locally grown food in season has the advantage of being less expensive than imported food. In addition, sun-drenched vegetables harvested in season have a flavor by far superior to that of hothouse vegetables.

Preservation is a creative art and affords enormous amounts of pleasure. As your experience grows you will be able to experiment with combinations of vegetables, herbs and spices to produce your own individual recipes.

Pickles are prepared for their own sake and as accompaniment to main dishes or drinks. The Lebanese pickling method is simple. Raw or lightly poached vegetables are preserved in salty acidulated water in a cool dark place for a certain length of time. Salt dissolved in water prevents microorganisms from flourishing in food. Vinegar in high concentration is also a preservative. Any glass jar or bottle is suitable provided it has or can be equipped with the correct airtight lids. With any preservative containing vinegar, tops should be not only airtight but also corrosion-resistant. They must either be plastic or must have cotton cloth dipped in paraffin wax, tied down over the mouth of the jar, before the lid is fitted on.

Use good vinegar and whole rather than ground spices tied in a muslin bag. Use young fresh vegetables. Wash and drain them well. Chop, shred or leave whole according to the recipe. Prepare the brine, and always pack the prepared vegetables into sterilized jars. Leave a head space of one inch at the top. Drain off any water that may have collected at the bottom, and then cover with the vinegar. Seal and store in a cool dry place. To mature, pickles need approximately 6-8 weeks unless otherwise mentioned in the recipe.

Pickled Cucumbers

kabīs khiyār

6 pounds small cucumbers
10 glasses of water
enough rock salt to float an egg
 (see **Brine** recipe)
6 cups vinegar
5 cloves garlic
2 small hot chili peppers

Dissolve the salt in the water and bring it to the boil. Set it aside overnight. The next day soak the cucumbers in the salted water and set aside overnight. The following morning drain the cucumbers and put them in sterilized jars, add garlic and hot peppers, and cover with vinegar. Seal the jars and store them. The pickles will be ready 3 months later. Just before they are ready to be eaten, remove them from the vinegar and replace the vinegar with water.

Pickled Eggplant

kabīs batīnjān

6 pounds very small eggplant
10 cloves garlic, crushed
3 red hot chili peppers, crushed
4 tablespoons coarse rock salt
2½ cups vinegar
4 cups water

Make an incision lengthwise in the eggplant for the stuffing and bring to the boil in salted water. Boil for 5-10 minutes until just slightly poached. Drain well in a colander.

Meanwhile, prepare the brine by dissolving the salt in water, bring to the boil and cool. Add the vinegar and set aside.

Mix the crushed garlic with the chili pepper and stuff the eggplant.

Place them in sterilized jars. Pour on the brine, seal and store. To be eaten 7 days later.

Pickled Cucumbers

khabīs khiyār

2 pounds small cucumbers
4 cloves garlic
1 teaspoon dried coriander
1 small green hot pepper
1 cup vinegar
3 cups water
4 tablespoons rock salt

Dissolve the salt in the water and fill a glass jar with it. Place the cucumbers in the jar and add the garlic, coriander, hot pepper and vinegar. Close the jar firmly and refrigerate. The pickles may be eaten one week later.

makdūs

Stuffed Eggplant in Olive Oil

makdūs

24 small white eggplants
10 cloves garlic, crushed
2 cups chopped walnuts
2 green chili peppers, chopped
1 tablespoon rock salt
1 cup seeds of sour pomegranate, optional
2 tablespoons dried coriander, optional
olive oil

Poach the eggplants and remove them to a container of cold water. Meanwhile mix the walnuts, garlic and peppers (the pomegranate seeds and coriander are also added here if desired).

Remove the eggplants to a colander to drain. Slit them open, squeeze out the rest of the water and stuff with the walnut filling. Lay them close together in a sterilized jar layered with salt. Stand the jar upside down for 2 days to drain. Cover with olive oil to the top. Seal and store and use 3 weeks later.

Pickled Turnips

kabīs lift

5 pounds turnips
2 cups vinegar
2 tablespoons rock salt
4 cups water
1 beet, sliced

Clean the turnips well under running water. Slice them into rounds or quarters and place them in a sterilized jar.

Dissolve the salt in water, bring to the boil, cool and add the vinegar. Pour the brine on to the turnips in the sterilized jar. Add the beet for color and close the lid tightly. Set aside for 5-7 days.

Pickled Cauliflower

kabīs arnabīṭ

1 large cauliflower, separated into florets
1 beet, quartered
1 cup vinegar
2 teaspoons rock salt
2 cups water
1 red chili pepper, optional

Prepare the brine by dissolving the salt in water. Bring to the boil, cool and add the vinegar. Place the cauliflower in a sterilized jar. Pour on the brine. Add the beet for color. Seal and store. May be eaten 4-5 days later.

Pickled Stuffed Cabbage

meḥshī malfūf makbūs

1 whole head of white cabbage
3 whole heads of garlic, coarsely chopped
3 teaspoons dried coriander
1 teaspoon hot red chili pepper
1 tablespoon salt
vinegar

Poach the cabbage leaves and slice the large leaves in half, removing the central vein. Set them aside to drain in a colander.

Prepare the stuffing by mixing the garlic, coriander and chili peppers. Take a slice of cabbage leaf and place a teaspoon of garlic and seasoning on it and roll. Lay the stuffed and rolled cabbage close together in a sterilized jar. Fill the jar with vinegar, leaving about an inch to the top. Seal and store to be used one week later.

Pickled Stuffed Green Peppers

meḥshī flayfleh makbūseh

12 medium green peppers
1 cup shelled peas
1 cup green haricot beans, topped, tailed and sliced
4 zucchini, coarsely chopped
1 small cauliflower broken into florets
3 green unripe tomatoes, coarsely chopped
10 cloves garlic, chopped
2 green or red chili peppers, chopped

Seed the green peppers and fill them with the mixture of all the above ingredients. Place them in a sterilized jar.

Dissolve 3 tablespoons rock salt in 8 cups water. Bring to the boil and cool. Add 4 cups vinegar. Pour the brine over the peppers in the jar. Seal well and store.

Pickled Mixed Vegetables

khudra makbūseh

1 pound carrots, sliced
1 pound small zucchini
1 pound small green unripe tomatoes
1 pound cauliflower, separated into florets
2 small green peppers
20 cloves garlic, peeled and left whole
½ pound green beans, topped and tailed
2 hot chili peppers

Brine
1 cup vinegar
5 cups water
2 tablespoons coarse rock salt

Place the ingredients in a large sterilized jar. Dissolve the salt in the water, bring to the boil, cool and add the vinegar. Pour the brine over the mixed vegetables in the jar, seal and store. To be eaten 20 days later.

Pickled Walnuts

kabīs al-jawz

10 pounds green immature walnuts
vinegar
brine – see recipe page 23

Soak the nuts in the brine for 3-4 days. Drain and cover with fresh brine and leave for a week. Drain thoroughly and spread on a large tray in the sun for 2 days until the nuts turn black. Pack them in sterilized jars and cover with the vinegar. To be eaten 6-8 weeks later.

Pickled Thyme

za'tar makbūs

1 pound fresh green thyme leaves
salt
1 cup vinegar
½ cup olive oil
brine – see recipe page 23

Add the vinegar and oil to the brine. Wash and dry the thyme leaves and place them in a sterilized jar. Pour the brine over them, seal and store.

Grape Vinegar

khall

over-ripe grapes
peel of 3 apples
peel of 3 pears

Crush the grapes and place them in a glass jar. Add the apple and pear peel, and set aside uncovered for one month. When foam forms and covers the top, push the grapes down with a wooden spoon. Cover the jar and leave it in a cupboard to ferment for another 2 months. When it turns to vinegar, strain and use.

Bottling
Preserves

What was once known as *conserve* in the early Middle Ages is known today as bottling. It is preserving food by heating it in airtight jars.

In the early days fruits were cooked in honey syrup, packed in containers and covered with a layer of oil to seal them. This method is still used in rural Lebanon. In the city, however, sterilizing pans complete with false bottoms and thermometers are used. Actually, any pot with a tight-fitting lid can be used provided the pot is 4 inches taller than the jar. Place a metal rack at the base of the pot to prevent any direct contact with heat. Immerse the jar in water, close the lid tightly, and boil for the required time.

Bottling has the advantage of preserving the natural flavor of the fruit or vegetable. Heating the container to the appropriate temperature for a specified time will destroy the microorganisms that spoil food. A simple bath of water heated to the required temperature is all that is needed. Fruits and tomatoes can be bottled in various forms: either whole or in pieces. Berries, which tend to disintegrate when heated, are often bottled as syrups and juices. Whatever food is bottled, one inch should be left between the food and the lid of the jar to allow for boiling.

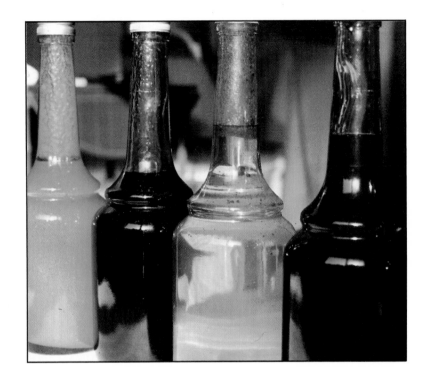

Green Beans Preserve

lūbiyeh makbūseh

6 pounds green beans, topped and tailed
½ cup olive oil
1 tablespoon salt
4 pounds ripe tomatoes, squeezed

Heat the oil, add the beans and salt and toss. Add the tomato juice and simmer until the beans are almost done but not quite. Remove them to warmed, sterilized airtight jars. Seal the jars and place them in a pot full of water enough to cover the jar, and leave 4 inches to the top.

Bring the water to the boil. Cook for exactly 20 minutes at 212°. Remove, cool and store. Use when the vegetable is not in season.

The same process may be applied to other green vegetables such as broad beans, okra, peas, etc.

Tomato Paste

rubb al-banadūra

20 pounds red, ripe tomatoes
2 cups coarse rock salt
½ cup olive oil

Mash the tomatoes well in a food processor. Add salt and blend well. Set aside overnight. The next morning strain to remove the seeds. Add the oil and simmer on very low heat until the juice thickens into a sauce.

Place the cooked tomato sauce in a large flat pan in the sun for 4 days, bringing it indoors at night. Mix the tomato sauce well daily. It may be stored when the consistency is that of a thick paste. Pour into sterilized jars, seal firmly, and process in a hot water bath for 20 minutes at 212°. Cool and store.

Pomegranate Molasses

dibs rummān

20 pounds sour pomegranates
1 tablespoon salt

Seed the pomegranates. To juice, place the seeds by the handful in a muslin bag and squeeze into a large bowl. In this manner the bitter white seed is strained and only the sour juice is obtained.

In a large brass pot, bring the juice to the boil and simmer until it is reduced to a thick concentrate, all the while skimming the foam as it rises.

To test if the syrup has thickened, remove it from the heat and put a drop on a cold saucer; the drop does not spread when the syrup is thick enough.

Add salt and simmer on very low heat for 3 minutes longer. Remove from the heat to cool. Pour into bottles and process in a hot water bath at 212° for 20 minutes. Store for use in cooking.

Sour Grape Juice

'aṣīr al-ḥuṣrum

unripe grapes
salt to taste
1 teaspoon olive oil

Crush the unripe grapes in a food processor. Strain and bring to the boil and remove to the side. Add salt to taste. Cool and pour into a sterilized bottle and add oil to the top to prevent mold, or process in a hot water bath for 20 minutes at 212°. Cool and store in a cupboard.

To be used in cooking.

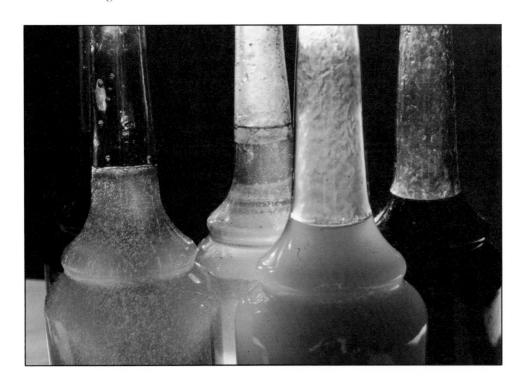

Lemon Syrup

sharāb al-laymūn al-ḥāmuḍ

1 cup lemon juice, strained
2 cups sugar

Dissolve the sugar in the lemon juice and simmer on low heat. Skim the froth with a spatula. Once it thickens into a syrup, remove to the side to cool. Fill sterilized bottles with the syrup. Grate the rind of the lemons and squeeze through cheesecloth to obtain the oil. Float a teaspoon of this oil on top of the syrup in the bottle. Close firmly and store to be used diluted in ice water as a refreshing drink.

Rose Water Syrup

sharāb al-ward

2 cups sugar
1 cup water
1 tablespoon lemon juice
1/3 cup rose water

Bring the sugar, water and lemon juice to the boil. Skim the top of the resulting froth. Simmer until it thickens into a syrup. Add rose water. Boil for 3 minutes. Remove, cool and pour into sterilized bottles, and process in a hot water bath for 20 minutes at 212°. Seal and store for later use diluted in ice water.

Mulberry Syrup

sharāb al-tūt

1 cup mulberry juice
2 cups sugar
1 tablespoon lemon juice

To obtain mulberry juice, use a wooden spoon to crush the mulberries through a sieve lined with cheesecloth. Bring to the boil with sugar and lemon juice, stirring continuously and skimming the froth. Reduce the heat and simmer until the syrup thickens enough to coat a spoon. Cool and pour into sterilized bottles and process in a hot water bath for 20 minutes at 212°. Store and serve diluted in ice water.

Rhubarb Syrup

sharāb al-rāwand (ribās)

10 pounds natural rhubarb
2 cups sugar

Remove the ends of the stalks from the rhubarb, scrape the fibrous skin from the stalks, and cut into 3-inch-long pieces.
 Bring the rhubarb to the boil in water and cook until done – about 10 minutes. Remove to a colander and drain. Squeeze the rhubarb through cheesecloth into a bowl. Dissolve the sugar in a little water and add the rhubarb juice. Boil, skimming the froth until the syrup thickens and its color is bright red – about 2 hours. Fill bottles with the syrup, seal and process in a hot water bath for 20 minutes at 212°. Cool and store to use diluted in ice water.

Date Preserve

mrabbā al-balaḥ

2 pounds fresh yellow or red dates
4 cups sugar
½ lemon
5 cloves
blanched almonds, one for each date

Peel the dates and bring them to the boil in enough water to cover. Simmer for one hour until soft. Drain and reserve the water.

Remove the pits and stuff each date with one blanched almond. Pour the reserved water into a pot and add enough cold water to make 3 cups. Add the sugar and lemon juice and bring to the boil. Simmer for a few minutes and add the dates. Continue simmering for 20 minutes.

Lift the dates out with a perforated spoon and place in sterilized jars. Add the cloves. Return the syrup to the heat and simmer until it thickens enough to coat a spoon. Pour the syrup over the dates, cool and seal. Process in a hot water bath for 20 minutes at 212°.

Eggplant Preserve

mrabbā al-bātinjān

2 pounds very small eggplants
½ pound sugar
2 lemons squeezed
½ cup rose water
1½ cups water

Top the eggplants and make an incision at the top in the form of a cross. In boiling water, bring the eggplants to the boil for 10 minutes until half done. Remove and squeeze out the water gently. Set aside in a colander to drain completely.

Meanwhile, prepare the syrup by dissolving the sugar in water and bringing it to the boil, stirring continuously. When the syrup has thickened, return the eggplant to the pot and simmer for 10 minutes. Let stand overnight. The following day, remove the eggplant from the syrup, and add lemon juice and rose water. Simmer the syrup over medium heat for 20 minutes. Once again return the eggplant to the pot and cook a while longer – about 10 minutes or until done. Pour the preserve into a warmed sterilized jar. Cool and seal. Process in a hot water bath for 20 minutes at 212°. Remove and store.

Bitter Orange Peel Preserve

mrabbā al-būṣfayr

2 pounds bitter oranges
2 cups sugar
2 cups water
½ lemon, squeezed

Grate the oranges lightly and peel in thin strips.

Bring the orange peels to the boil in water for 30 minutes. Remove and soak in cold water for 2 days, changing the water twice a day. Remove to drain in a colander. Roll and thread on a string like a necklace.

Prepare the syrup by dissolving sugar in water and bringing it to the boil. Add lemon juice and simmer until the syrup thickens. Drop the bitter orange peels in the syrup and simmer for 30 minutes. Unthread and remove to a sterilized jar. Boil the syrup to reduce it and pour into the jar. Cool, seal and process in a hot water bath at 212° for 20 minutes.

Green Walnut Preserve

mrabbā al-jawz

1 pound green walnuts
2 cups sugar
1½ cups water
1 tablespoon lemon juice
4 cloves

Remove the outer shell from the walnuts leaving them whole and soak in water for 4 days. Change the water twice daily to remove all bitterness.

Dissolve the sugar in water on medium heat stirring continuously. Add the lemon juice and simmer, stirring all the time until the syrup thickens enough to coat a spoon. Set aside to cool. Drain and drop in the walnuts and bring the pot to the boil. Simmer for 20 minutes and set aside overnight. The following day, once again bring the preserve to the boil and simmer for 30 minutes. Add the cloves and pour into sterilized jars. Process in a hot water bath for 20 minutes at 212°. Cool and seal.

Whole Fig Preserve

kwāz tīn bi-sikkar

5 pounds green unripe figs
3 pounds sugar
1 teaspoon cloves
1 teaspoon ground mistki
2 leaves rose-geranium
2 lemons, juiced

Dissolve the sugar in 2½ cups water. Add the rose-geranium and bring to the boil.

Drop in the figs and simmer on a very low heat until the syrup thickens. Just before removing the pot from the heat, add lemon juice and *mistki.* Stir well, cool and store in sterilized jars. Process in a hot water bath for 20 minutes at 212°.

Jams

Preserves produced by boiling fruit with sugar are known as jams. Jam-making is one of the most common methods of preserving fruit. No Lebanese home is without its jars of jams sitting on the pantry shelves. Jams can be made from any fruit. The methods remain basically unchanged from the time of our grandmothers. The fruit is simmered until tender, sugar is added and the mixture is cooked until it thickens and sets; timing is of the utmost importance. If the jam is boiled for too long, the sugar will caramelize and the jam will become dark and thick; if it is boiled too briefly, it will remain too liquid.

Traditionally, when the syrup coats the back of a spoon, the jam is ready, provided there is enough acid or lemon juice. Some general rules are worth remembering when making jams: Always make certain that the sugar is fully dissolved before bringing the jam to the boil, otherwise the texture will be granular, and skim the top of the resulting froth; when making jam never cover the pot; evaporation is an important step in the process; always store jam in sterilized jars in a cool dark cupboard or pantry.

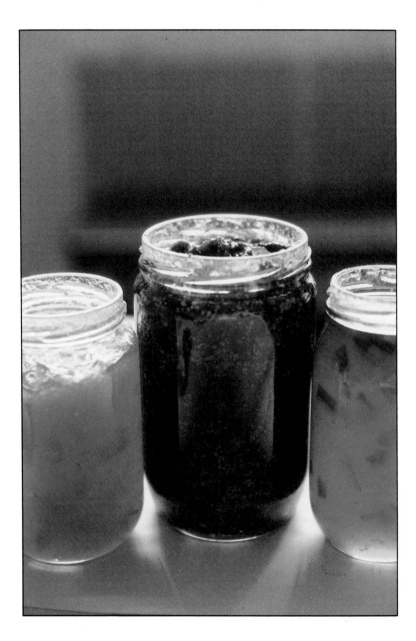

Dried Fig Jam

tīn bi-sikkar

2 pounds dried figs, coarsely chopped
2 cups sugar
1 teaspoon anise
2 cups water
2 rose-geranium leaves, tied together
¼ teaspoon ground mistki
1 lemon
½ cup sesame seeds

Dissolve the sugar in water and bring to the boil. Add the dried figs, lemon, rose-geranium, anise and *mistki*. Simmer until the syrup thickens. Remove the rose-geranium and set the syrup aside. Meanwhile, toast the sesame seeds and remove to absorbent paper to cool.

Sprinkle the sesame seeds on the jam and pour into sterilized jars. Cool and seal.

Cherry Jam

mrabbā al-karaz

2½ pounds cherries
1¼ pounds sugar
3 cups water
½ lemon, juiced

Soak the cherries in enough water to cover for 24 hours. Drain and pit.

Bring the water to the boil in a deep pot. Add the cherries and bring to the boil slowly for about 5 minutes. Skim the resulting froth. Remove the cherries to the side with a flat perforated spoon. Add sugar and lemon to the pot and boil. Return the cherries and simmer gently until they are soft and the syrup is thick. Lift the cherries to sterilized jars. Reduce the syrup further if necessary and pour over the cherries. Cool, seal and store.

Rose Petal Jam

mrabbā al-ward

1 pound fresh red eglantine rose petals
 (Damascus rose petals)
2 cups sugar
2 lemons, squeezed
2 tablespoons rose water

Bring the rose petals to the boil in water. Simmer until tender, 5-10 minutes. Drain and soak in the lemon juice.

Prepare the syrup by dissolving the sugar in 2 cups of water. Bring to the boil. Add the rose petals and let stand for a few hours. Return to the heat and simmer for 10 minutes. Skim and add the lemon juice and rose water. When the syrup has thickened remove to sterilized jars. Cool, seal and store.

Sundrenched Apricot Jam

mrabbā al-mishmosh

2 pounds dried apricots
2 pounds sugar
2 cups water
a pinch of citric acid

Dissolve one cup of sugar in water. Drop in the apricots and bring to the boil. Remove immediately to a deep bowl. Add the remaining sugar and citric acid to the syrup and boil until it coats a spoon. Pour the syrup over the apricots and place the bowl in the sun for 8 days. Stir gently daily. Store in sterilized jars.

Quince Jelly

mrabbā al-sfarjal mṣaffā

4 quinces
2 cups water
1 cup sugar

Wash and slice the quinces with their skins. Boil in very little water for 30 minutes. Remove and squeeze out the juice by rubbing the fruit through a fine sieve, or by placing it in cheesecloth and squeezing. Use the juice and dissolve the sugar in the juice, adding enough water to make 2 cups. Bring to the boil stirring continuously until the syrup thickens. Cool and store in sterilized jars.

Quince Jam

mrabbā al-sfarjal

2 pounds quince
1 pound sugar
1 cup water

Wash the quinces, remove seeds and slice. Place the slices in a pot layered with sugar. Add water and simmer until tender – about one hour. Skim the froth and simmer 30 minutes until the color turns dark red. Pour into sterilized jars and set aside uncovered to cool. Seal and store.

Apricot Jam

mrabbā al-mishmosh

2 pounds fresh apricots
1½ pounds sugar

Stone the apricots, place them in a bowl layered with sugar and set aside overnight. The following day bring the mixture to the boil. Skim the froth, reduce the heat and simmer for 30 minutes, stirring occasionally, until the apricots are soft and the syrup has thickened enough to coat a spoon.

Pour into sterilized jars. Cool, seal and store.

Sour Black Cherry Jam

mrabbā al-karaz al-barrī

2 pounds sour cherries, pitted
2 pounds sugar
½ lemon, juiced

Place the cherries and the sugar into a large porcelain or earthenware bowl overnight. The following day, place the cherries and their juice with the lemon juice in a large pot and bring to the boil, stirring frequently. Skim the froth and simmer for 30 minutes. Add a little water if necessary.

When the syrup has thickened enough to coat a spoon, pour the jam into the sterilized jars, and allow to cool before sealing and storing.

Candied Fruits

Candying fruits is an old time-consuming but popular method of preserving fresh fruits in the Middle East. These candied fruits are usually bought from specialized shops. However, the process is not difficult and is quite possible to do at home. It does, nevertheless, require 2 weeks to complete. It consists of covering the fruits with a hot spicy syrup flavored with cinnamon or *mistki*, and gradually increasing the sugar until the fruits are completely impregnated with it. The idea is to gradually allow the fruit juices to drain and the syrup to replace them.

Apricots, pears, plums, even orange peels, are candied in this manner. Use good quality fresh fruits, neither over-ripe nor under-ripe. Candy one fruit at a time. Peel, if the fruit needs peeling, halve or leave whole, and place the fruit in boiling water to cover, and cook until just tender. Drain the fruit and reserve the liquid. Dissolve in every cup of reserved liquid, 12 tablespoons of sugar. Put the fruit in a bowl and pour the syrup on top. Add more syrup if necessary to submerge the fruit. Set aside for 24 hours. The following day drain the syrup into a pan and add 3 tablespoons of sugar. Heat until the sugar is dissolved. Return to the fruit bowl for another 24 hours. Repeat the

process for 2 more days, each time adding 3 tablespoons of sugar to the syrup, heating and returning to the fruit. On the fifth day, add 5 tablespoons of sugar to the syrup, dissolve, and this time, add the fruit and simmer for 5 minutes. Return to the bowl and let stand for 48 hours. Repeat the last process and set aside this time for 4 more days. Drain off the syrup and lay the pieces of fruit on a wire tray over a pan in an airy cupboard. The fruits will dry in 48-72 hours. To add a final touch, crystallize or glaze the fruits.

To **crystallize,** dip the fruit in boiling water and roll in fine granulated sugar. To **glaze,** dissolve one pound of sugar in ½ cup water and bring to the boil. Keep the syrup hot and dip the candied fruits in boiling water first and then in the thick hot syrup. Remove immediately to a wire tray. Place the wire tray in a very slow 120° oven to dry.

Freezing

Freezing at home, as a method of preserving food, was unknown to our grandmothers. They had what was known as the cold room lined with blocks of ice, where perishable food was kept. Today, freezing has become a popular method of preserving food in most homes.

Properly used, freezing can provide a variety of foods throughout the year, particularly when the supply of fresh fruits and vegetables is limited. As a method, it is foolproof. It is important, however, to remember that all foods have a period of satisfactory storage. Freezer temperatures do not stop the chemical changes that spoil food; they only slow down their action. Food must be frozen quickly to prevent ice crystals from forming, which cause the moisture and juices to run out of the food. Food to be frozen must be in perfect condition. Start by preparing small quantities of food at a time, blanch the vegetables, and cool hot foods rapidly prior to freezing.

Since air will cause frozen food to deteriorate, exclude as much air as possible when packing and use airtight containers.

Freezing Fruits

One method of freezing is open freezing. It is very suitable for freezing berries and all types of soft fruits whose shape you wish to retain. Hull the fruits, rinse only if necessary, and place on trays in single layers with the fruits well apart. Freeze for 2 hours, and when the fruits are firm, pack them away in plastic bags or airtight containers. A fruit frozen in this way remains whole. To save time, if the appearance of the fruit is not important, cook, cool, seal and freeze it.

Whatever the method of freezing, all fruits must be thawed slowly in unopened packets to prevent discoloration.

Freezing Vegetables

Most vegetables require blanching before freezing. This helps to retain the color and conserve the nutritive value. Certain vegetables such as broad beans, green beans and peas can be open frozen (see above in section on freezing fruits). Salad greens do not freeze well because of their high water content that leaves them limp after thawing.

There are some essential rules to remember when blanching vegetables. Use for each pound of vegetables, 12 cups of lightly salted boiling water. Return the water to the boil after the vegetables have been dropped in it. Blanching time is anywhere from 2-5 minutes (carrots and artichokes require 5 minutes, cauliflower, zucchini, peppers, potatoes, and spinach, all require 2-3 minutes).

After blanching plunge the vegetables in cold water to stop the cooking process. Cool, drain well, pack and freeze.

Nuts

Walnut, almond, pistachio and pine trees are all part of the Lebanese rural scene. The dry fruits of these trees or nuts are very important in the Lebanese diet. They are used in sauces, in pilafs, as snacks, but above all, in sweets and desserts. Except for pine nuts, almonds, pistachios and walnuts can all be dried in their shells and stored. Nuts in shells store longer than shelled nuts.

Gather the nuts when the hard shell has formed inside. Spread them out to dry in the sun or in an airy cupboard. Rub off the outer husk but leave the shell on. Scrub them in cold water and place them on trays, in a 50°-150° oven. Turn them occasionally. When dry, pack them into glass jars layered in salt.

Salted Almonds

Lawz mḥammaṣ

1 pound shelled dried almonds
5 tablespoons olive or salad oil
2 tablespoons salt

Put the shelled nuts in the grill pan for 2-3 minutes. Rub the skin off. Heat the oil in a heavy-based pan. Add the nuts and stir gently until golden. Stir in the salt on very low heat until all the nuts are coated with salt. Remove to absorbent paper to drain. Cool and store in airtight containers.

Part Two

IN THE KITCHEN

Once in the kitchen, today's cook wishing to tackle Lebanese dishes need not be concerned much with acquiring specialized utensils. For general cooking and long-stewing dishes, heavy-based pots and pans will do the job. One or two baking trays will be needed to prepare sweets and *kibbeh* and a zucchini or apple corer will make the task of preparing stuffed eggplant and zucchini much easier.

The one modern appliance that is tailor-made for the Lebanese cook is the food processor. It purées everything from eggplant for *mtabbal*, to chickpeas for *hummus*; it chops large quantities of herbs and onion; it grinds nuts for the sauces and sweets, and grates cheeses for omelettes. Some cooks will want to keep handy the mortar and pestle traditionally used for grinding, if only to pound nuts, spices and garlic.

For the successful preparation of the following recipes, you need only use the recipes as a guide, tasting and adjusting as you cook until the final result has your own stamp on it. This is very much in the tradition of the Lebanese, whose home cooking has always included little individual touches, allowing the cook to lay proud claim to favorite dishes.

Laban and Cheese

The making of *laban* is a creative ritual in the Lebanese household. With experience, the cook learns the exact temperature required to turn the milk into *laban*. The traditional way is to dip the finger in the cooling milk and to count to 10 before the starter is added. The milk must be hot enough to sting but not too hot that you cannot keep your finger in it.

You will soon realize that many Lebanese dishes call for *laban*, fresh or cooked. Cow's milk curdles when cooked and must, therefore, be stabilized by the addition of cornstarch or eggs. On the other hand, *laban*, made from goat's milk is in no danger of curdling when cooked. The latter is favored by the Lebanese cook for its more pronounced taste. Always reserve a coffee cup of ready *laban* to use as a starter for a fresh batch.

Almost as important as *laban*, is the cream cheese made from it called *labneh*. While Lebanese cheeses are generally made by curdling milk and straining the curds of their whey, it is the *labneh* made by straining *laban* that steals the show. *Labneh* may be served in countless ways, plain or mixed with thyme and sprinkled with olive oil, or blended with garlic and hot pepper as a dip, or mixed with onion and parsley as a filling for pastry. However it is served, it remains a favorite with children and adults alike.

If you don't wish to make your own, *laban* and *labneh* are available at Middle Eastern markets.

Yogurt

laban

8 cups whole milk
½ cup starter or laban from a previously prepared batch

Bring the milk to the boil. Remove from the heat and set aside to cool to 110° or until you can dip your finger in it and count to 10.

Thin out the *laban* starter in a little milk, and stir into the milk. Wrap the bowl with a woollen blanket and let it stand for 4-6 hours in a warm place. When it has set, refrigerate for 2 hours before using. New batches of *laban* are best made every 3 to 4 days using the starter from the previous batch.

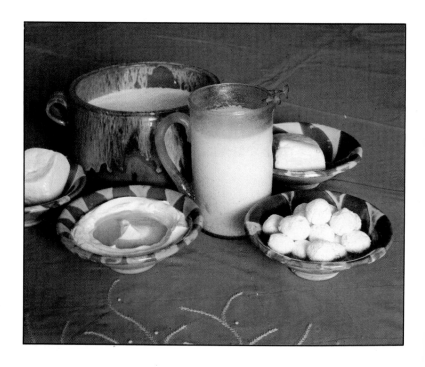

Cooked Laban

laban maṭbūkh

4 cups laban
1 tablespoon cornstarch blended in a little cold
 water (or 1 egg)
1 teaspoon salt

Beat the *laban* well, add the blended cornstarch or egg, salt and stir well. Bring to the boil gently, stirring continuously with a wooden spoon. Reduce the heat and simmer for 10 minutes or until the *laban* is of a thick soup-like consistency. Always stir the *laban* in one direction only, otherwise it will fail. Use for any of the recipes that call for cooked *laban*.

Laban Drink

'ayrān

2 cups laban
1 cup water
1 teaspoon salt
crushed dried mint leaves, optional

Beat the *laban* well in a large mixing bowl. Use a blender to get the best result. Add water and salt. Add more water if the *laban* is very thick. Blend well. Chill and serve, sprinkled with crushed mint (optional).

Laban Cream Cheese

labneh

4 cups laban prepared according to the recipe
 on page 42
salt to taste

Mix the *laban* with salt and pour into a cheesecloth bag. Hang overnight until all the liquid is drained, leaving the *labneh* a thick creamy consistency. Use as filling for *sambūsek* page 130, or serve it with olive oil and bread as a cheese.

Laban Cheese Balls in Oil

labneh mkabtaleh makbūseh

Prepare the *labneh* as described in the recipe above, using goat's milk instead of cow's milk. It gives the *labneh* a sharper taste. If goat's milk is unavailable, use cow's milk but allow the *labneh* to drain completely of its liquid and add more salt.

 Roll the *labneh* into small marble size balls. Chill and pack into sterilized jars. Cover with olive oil, seal and store. To serve, use some of the olive oil to soften the *labneh*.

White Cheese

ḥallūm

*8 cups whole sheep's milk (cow's milk may
 be substituted)*
3 tablespoons cold water
3 rennet junket tablets
salt
½ teaspoon black cumin seeds

Dissolve the rennet tablets in cold water.
Warm the milk to 95°. Add the rennet and
stir gently. Cover and set aside for ½ hour.

With a wire whisk, stir the milk to break
the curds. Strain through a piece of
cheesecloth, collecting the whey in a
receptacle. Once the milk is drained of its
whey, remove the curds to a board and
shape into rectangles 2 inches in thickness.
Fold a piece of cloth over them and press
down to drain all the remaining liquid or
whey. In a pot bring the resulting whey to
the boil.

Cut the curds into quarters and drop into
the boiling whey. Cook until the cheese
floats. Remove the pot to the side. While
hot, press the cumin seeds into the cheese.
Dip the warm cheese in salt and set aside to
cool. The cheese may be eaten fresh. If it is
to be stored, dissolve a little salt in 2 cups of
whey enough to cover the cheese and pour
it over it in a sterilized jar. This cheese may
be eaten one month later.

Lebanese Ricotta

arīsheh

*The reserved whey from the first step in the
 hallūm cheese (previous recipe)*
4 cups milk
2 tablespoons lemon juice

Bring the whey to the boil and add the milk
and lemon juice. Return to the boil stirring
continuously with a wooden spoon. Reduce
the heat and simmer until curds form –
about 15 minutes. Once the curds form,
remove the pot from the heat and set aside
to cool – about 10 minutes.

Strain over a receptacle through a piece of
cheesecloth, collecting the whey. Hang the
cheesecloth over the sink for 2 hours. The
cheese is ready when it has the consistency
of a dry cottage cheese. Refrigerate and use
the next day.

It may be eaten plain with bread, with
honey or sprinkled with sugar.

White Goat Cheese

jibneh khaḍra

10 pounds goat's milk (room temperature)
½ rennet tablet

Dissolve the rennet tablet wrapped in a sachet of cheesecloth in the milk. Set aside for 2 hours. Test with a match stick to see if the milk has set. Mix well and pour into a cheesecloth to drain. Collect the whey and set it aside.

Form the resulting cheese into balls. Pinch in the middle, add a dash of rock salt and chill. Dissolve the whey in water and store the cheese in it to keep it fresh.

Toasted Cream

jmaysh

½ pound (8 oz.) heavy cream or clotted cream
 or ashta (see page 134)
½ cup powdered milk dissolved in 2
 tablespoons water
1 teaspoon salt

In a nonstick pan and over very low heat, blend the cream and powdered milk, stirring continuously, to keep from curdling until the mixture browns. Add salt, mix well and serve with flat Arabic bread or pita bread for breakfast.

Curd Cheese

ambarīs

This unusual cheese requires 7 months to make. It is included in this book merely to note an old tradition rather than to provide a recipe. But for those who are brave enough to try making this cheese, all that is required is an earthenware jar with a hole drilled near the bottom on the side of the jar. This hole is to drain all the liquid from the curdling milk. The rural cook stops the hole with a piece of cane that protrudes 2 inches outside the jar. The mouth of the jar is covered with a piece of cotton cloth held down by a string wrapped around it.

Half fill the jar with cow's milk and leave it in a cool place until the milk turns. Every two days rotate the cane in the hole to force the water from the curdled milk to drain. Add more milk (this time goat's milk) and rock salt to taste to the jar, and leave it for a few more days. Once again drain the water and add more cow's milk and salt. Continue the process alternating cow's milk with goat's milk. This process must go on from May to October. When the cheese is ready, remove it to sterilized jars and store in the refrigerator. It is delicious with *marqūq* bread (page 16).

The Egg

An egg is simple unembellished nourishment. It is one of nature's most complete foods. It contains vitamins, minerals and all the essential amino acids needed for growth. In addition, it is one of the least expensive sources of protein on the market.

In Lebanon, eggs are the foundation for many tantalizing dishes. The omelette is particularly popular mixed with a variety of vegetables. It is traditionally served round, flat and cooked on both sides, or in the form of small individual patties. The lighter omelette inspired by the French has been recently adopted by the Lebanese and adapted to their special taste for flavoring.

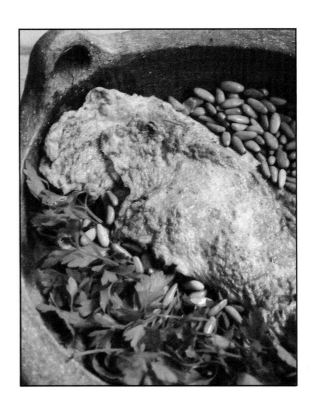

Pine Nut Omelette

'ijjeh bi-ṣnūbar

6 eggs
2 tablespoons pine nuts
2 tablespoons butter
1 small onion, finely chopped
2 tablespoons parsley, finely chopped
salt and bhar

Beat the eggs and add the parsley, onion, pine nuts and seasoning. Heat the butter in a pan and pour in the egg mixture. Reduce the heat and cook until the eggs have set. Brown the omelette on both sides and serve garnished with slices of tomato. Serves 4.

Traditional Herb Omelette

'ijjeh 'arabiyyeh

6 eggs, well beaten
2 tablespoons oil or butter
1 small onion, finely chopped
3 tablespoons parsley, chopped
salt and pepper

Rub the onions with salt and pepper and add the chopped parsley. Fold in the eggs and stir with a wire whisk. Heat the oil in a pan and pour in the egg mixture. When the eggs have set, turn over and brown the other side. Serve the omelette immediately. Serves 4.

Potato Omelette

'ijjet baṭāṭa

6 eggs
2 tablespoons butter or oil
2 potatoes, boiled and chopped
1 tablespoon chopped parsley
salt and pepper

Beat the eggs well and season with salt and pepper. Heat the oil and pour in the eggs. When they have set, place the potatoes and parsley in the center of the omelette and fold it over. Serve immediately. Serves 4.

Mashed Potato Omelette

'ijjet baṭāṭa purée

6 eggs
2 medium potatoes, boiled and mashed
1 tablespoon parsley, chopped
2 tablespoons onions, finely chopped
salt and pepper

Beat the eggs and fold in the potatoes, onions and seasoning. Beat the mixture well. Heat the oil and pour in the egg mixture. Cook over very low heat until the eggs have set. Turn the omelette over to brown the other side. Remove it to a flat dish, garnish with the chopped parsley and serve hot. Serves 4.

Thyme Omelette

'ijjeh bi-za'tar

6 eggs, beaten
2 tablespoons chopped onions
2 tablespoons oil or butter
3 tablespoons chopped fresh thyme
salt and pepper
pinch of cinnamon

Rub the onion with the thyme, salt, pepper and cinnamon. Add eggs and beat well with a fork.

Heat the oil or butter in a large pan and pour in the egg mixture. When the eggs have set, turn the omelette over and brown the other side. Remove to a flat dish and serve immediately. Serves 4.

Zucchini Omelette

'ijjet kūsā

6 eggs
3 small zucchini
1 onion, finely chopped
1 clove garlic, chopped
2 tablespoons oil or butter
1 teaspoon cinnamon
salt and pepper

Wash, scrape and chop the zucchini. Boil them in a little water until tender but firm. Drain in a colander for 30 minutes.

Heat one tablespoon of oil in a large pan and sauté the onions and garlic until golden. Season with salt and pepper and remove to absorbent paper to drain. Add the zucchini to the pan and toss for one minute.

Beat the eggs well and season with cinnamon, salt and pepper. Fold in the zucchini mixture. Heat the remaining oil and pour in the egg mixture. Cook on low heat until the eggs have set. Turn over to brown the other side. Serve the omelette hot. Serves 4.

Fennel Omelette

'ijjeh bi-shummar

6 eggs
2 tablespoons chopped green fennel
4 spring onions, finely chopped
1 tablespoon flour, mixed with water into
 a paste
1 tablespoon butter or oil
salt and pepper

Beat the eggs lightly and blend in the flour, fennel and onion. Season with salt and pepper. Heat the oil in a large frying pan and pour in the mixture. Cook until the omelette is golden, flip it over, and cook on the other side. Serve flat. Serves 4.

Vegetable Omelette

'ijjet khudrā

6 eggs
1 carrot
1 small zucchini
1 potato
1 tablespoon chopped parsley
2 tablespoons butter
salt and pepper to taste

Wash and chop the vegetables. Boil in very little water until they are done but still firm. Heat one tablespoon of butter and sauté the vegetables. Remove to absorbent paper to drain. Beat the eggs lightly. In a separate pan, heat the remaining butter and pour in the eggs. When the omelette begins to set, place the vegetables in the center and fold. Garnish with the chopped parsley and serve immediately. Serves 4.

Cheese Omelette

'ijjeh bi-jibneh

6 eggs
1 cup grated cheese, sharp cheddar or
　　kashkawan
½ cup milk
2 tablespoons butter
½ teaspoon Dijon mustard
salt and pepper to taste

Beat the eggs well and fold in the grated cheese. Add the milk and mustard and season with salt and pepper to taste. Beat the mixture well. Heat the butter in a large frying pan and pour in the egg mixture. When the eggs have set, turn over to brown the other side. Serve the omelette sprinkled with grated cheese. Serves 4.

Fresh Broad Bean Omelette

'ijjeh bi-fūl akhḍar

6 eggs
½ pound fresh or frozen broad beans or fava
　　beans, shelled
1 onion, finely chopped
1 clove garlic, chopped
1 bunch fresh coriander, chopped (or 1
　　tablespoon dried)
2 tablespoons oil or butter
salt and pepper to taste
¼ teaspoon cinnamon

Boil the broad beans until tender. Drain thoroughly and remove the outer skin. Heat the oil and sauté the onions. Add the garlic and coriander and toss for 2 minutes. Add the broad beans and stir on low heat for a few minutes. Beat the eggs lightly and season with salt, pepper and cinnamon. Pour them over the beans. When the omelette has set, remove to a flat round dish. Serve immediately. Serves 4.

Spinach Omelette

'ijjeh bi-sbēnekh

½ pound spinach
6 eggs
2 tablespoons butter or oil
2 tablespoons finely chopped onions
1 clove garlic, crushed
2 tablespoons pine nuts
1 tomato, skinned, seeded and chopped
salt and pepper

Wash the spinach thoroughly. Drain and chop it. In a cooking pot, toss the spinach in its own juice until it wilts.

In a pan heat the oil and sauté the garlic, onions, tomatoes and seasoning, and add the spinach.

Beat the eggs lightly and pour them over the mixture. Stir and cook until the eggs have set.

Meanwhile, brown the pine nuts in a little butter. Sprinkle them on the omelette and serve immediately. Serves 4.

Lebanese Village Omelette

'ijjet al-ḍay'a

6 eggs
1 onion, finely chopped
3 tablespoons chopped parsley
1 tablespoon chopped fresh mint leaves
 (or ½ teaspoon dried)
1 tablespoon flour, mixed with a little water
 to make a paste
salt and pepper to taste
a pinch of cinnamon
2 tablespoons oil or butter

Rub the onions with salt and pepper and cinnamon. Add the eggs, flour, parsley and mint. Beat the mixture well. In a large frying pan, heat the oil and drop the egg mixture by the spoonful into the hot oil to form a patty. Cook both sides. When it turns a golden color, remove to a platter. May be served hot or cold. Serves 4.

Egg and Artichoke Patties

'ijjeh bi-arḍishawkī

6 fresh artichokes
6 eggs
½ cup finely chopped onions
1 tablespoon oil
1 tablespoon butter
1 lemon, squeezed
salt and pepper to taste
1 tablespoon flour mixed with cold water

Stem and remove the leaves of the artichoke. When you get to the hearts, clean out the choke and rub the hearts with lemon juice. Chop and set aside. Heat the butter and sauté the onions and artichoke hearts lightly. Beat the eggs with the flour and fold in the onion and artichoke mixture. Season with salt and pepper to taste.

Heat the oil in a large frying pan. Drop the egg mixture by the spoonful into the hot oil. Cook the patties on both sides until golden. Serve garnished with slices of tomatoes. Serves 4.

Baked Eggs and Zucchini Pulp

na'r kūsā bi-bayḍ

2 pounds zucchini
5 eggs, beaten
1 large onion, finely chopped
3 medium tomatoes, skinned, seeded
 and chopped
2 tablespoons olive oil
salt and allspice or bhar

Core the zucchini and use only the pulp. Reserve the zucchini shells for another recipe. See page 87.

Heat the oil, sauté the onions until transparent. Add the tomatoes and season. Add the zucchini pulp and cook until done, about 10 minutes. In a small cake mold, blend the pulp mixture with the eggs and bake in a medium oven at 350° until the eggs have set – about 5 minutes. Unmold and serve immediately. Serves 4.

Eggs With Laban

bayḍ bi-laban

8 eggs
2 tablespoons butter or oil
1 cup laban
salt and pepper

Beat the *laban* smooth using a fork or wire whisk. Heat the oil in a pan. Break the eggs into the pan and season. When the eggs have set pour in the *laban*. Serve immediately with flat Arabic bread. Serves 4.

Eggs Poached in Cooked Laban

shmāmīṭ

8 eggs
2 cups laban
1 tablespoon cornstarch, mixed with a little
 water
10 cloves garlic, crushed
3 tablespoons butter or samneh
1 teaspoon salt
2 teaspoons crushed dried mint leaves

Beat the *laban* in a large mixing bowl until it is liquid and smooth. Add the blended cornstarch and a little salt. Bring to the boil in a heavy pan stirring continuously. Reduce the heat and continue cooking until the *laban* is of a rich thick consistency.

Meanwhile, sauté the garlic in a little butter or *samneh* and add it to the cooking *laban*. Pour the hot *laban* into an ovenproof dish. Break the eggs into it and bake for 15 minutes. When the eggs have set, remove and serve sprinkled with crushed mint leaves. Serves 4.

Layered Eggs with Laban and Bread

fatteh sājiyyeh

2 cups laban
3 eggs
½ cup chopped parsley
2 tablespoons tahini
½ cup pine nuts
2 tablespoons butter or samneh
1 loaf stale bread, broken into croutons
3 cloves garlic, crushed
salt to taste

Blend the *laban* with the *tahini* and garlic and set aside.

Sauté the pine nuts in butter or *samneh* until lightly browned and set aside.

Place the croutons in a deep serving dish. Pour the *laban* over them and top with chopped parsley.

Fry the eggs in butter and place on the parsley layer. Top with pine nuts and butter or *samneh* and serve immediately. Serves 4.

Eggs with Sumac

bayḍ bi-summa'

8 eggs
1 tablespoon oil or butter
1 teaspoon sumac
1 clove garlic, crushed (optional)
a pinch of dried mint (optional)
salt and pepper

Heat the oil or butter in a large frying pan. Add the garlic and mint and stir. Break in the eggs and add the seasoning. Sprinkle on the *sumac* and cook until the eggs have set. Serve immediately with flat Arabic bread. Serves 4.

Eggs and Tomatoes

mfarraket bayḍ bi-banadūra

8 eggs
1 onion, finely chopped
3 cloves garlic, chopped
4 medium tomatoes, skinned, seeded
 and chopped
2 tablespoons chopped parsley
3 tablespoons butter
¼ teaspoon cinnamon
salt and pepper to taste

Sauté the onions and garlic until golden. Add the parsely and sauté a little longer. Fold in the tomatoes. Season with salt, pepper and cinnamon. Cover and cook for 10 minutes on low heat. Beat the eggs lightly and fold them in. Stir in the mixture gently and cook until the eggs have set. Garnish with parsely and serve immediately. Serves 4.

Variation

Scrambled Eggs with Tomatoes

bayḍ bi banadoūra shakshūka

3 tomatoes, skinned and finely chopped
1 onion, finely chopped
6 eggs
¼ cup olive oil
¼ teaspoon red chili pepper
½ teaspoon salt

Heat the oil and sauté the onions. Add the tomatoes and sauté longer. Break the eggs over the tomato mixture and stir with a fork to scramble. Season with salt and chili pepper and cook covered for 2 minutes. Serve immediately. Serves 4.

Fried Eggs with Pomegranate Molasses

bayḍ bi-dibs rummān

6 eggs
2 tablespoons olive oil
1 clove garlic, crushed
1 tablespoon pomegranate molasses
salt and black pepper
½ teaspoon crushed, dried mint leaves

Mix the pomegranate molasses with oil, mint leaves, salt and pepper and set aside. Heat the oil in a pan, and break the eggs in it. When the eggs have set, add the pomegranate molasses and cook for one minute. Serve hot. Serves 4.

Eggs in Cream

bayḍ bi-krēma

1 cup heavy cream
6 eggs
salt and pepper

Bring the cream to the boil, and break the eggs in it. Add salt and pepper. Cook until the eggs have set and serve immediately. Serves 4.

Fried Eggs with Onions and Garlic

bayḍ mī'lī ma' tūm wa baṣal

6 eggs
2 tablespoons oil or butter
2 tablespoons finely chopped onion
1 clove garlic, crushed
salt and black pepper

Soften the onions in the butter, add the garlic and season with salt and pepper. Break the eggs on the mixture and cook until they have set. Serve immediately. Serves 4.

Eggs with Peppers and Tomatoes

mfarraket bayḍ bi-flayfleh

6 eggs
1 small onion, chopped
1 green pepper, chopped
2 medium tomatoes, peeled and chopped
2 tablespoons oil
salt and pepper

In a large frying pan sauté the onions and pepper until tender. Add the tomatoes and season with salt and pepper. Cook on low heat until the mixture is soft. Correct the seasoning and break the eggs on the mixture. Stir and cook until the eggs have set. Remove to a serving dish and serve immediately. Serves 4.

Eggs with Hallūm Cheese

bayḍ mi'līma' Ḥallūm

6 eggs
6 slices of hallūm cheese
1 tablespoon butter
salt and pepper

Fry the cheese slices in hot butter and just as they begin to melt break the eggs over them. Cook until the eggs have set.

Season and serve with flat Arabic bread. Serves 4.

Eggs and Zucchini Casserole

alēb kūsā ma'bayḍ

8 eggs
5 zucchini
1 large onion, finely chopped
2 tablespoons butter
2 cloves garlic, crushed
1 teaspoon salt
1 teaspoon allspice
½ cup breadcrumbs

Heat the butter and sauté the onions and crushed garlic. Wash, scrape and chop the zucchini. Add them to the onions and mix well together. Cover and simmer until the zucchini are done but firm. Beat the eggs lightly and fold in. Season and blend the mixture. Pour it into an ovenproof casserole and sprinkle with breadcrumbs. Dot the casserole with butter and bake in a 450° oven for 15 minutes. Serves 4-6.

Variation

Follow the above recipe and substitute eggplant for the zucchini.

Eggs with a Spicy Walnut Sauce

bayḍ bi-jawz

6 hard-boiled eggs
½ cup shelled walnuts
½ loaf French bread
3 onions
½ teaspoon red hot chili pepper
¼ cup lemon juice
salt and pepper

Slice the eggs in rounds and place them on a flat dish. Slice the onions in rounds and place one slice on each slice of egg. Prepare the walnut sauce by removing the crust of the bread and soaking the pulp in water. Crush the walnuts well using a pestle and mortar or a food processor, and add the soaked pulp. Blend well adding water until the mixture is of a thick creamy consistency. Add the lemon juice and season with salt and pepper. Pour on top of the eggs and sprinkle with red pepper. Serves 4.

Salads

mixed salad

Over the years the Lebanese have reached into their gardens to create an infinite variety of salads to accompany every type of meal. Fresh raw vegetables, cooked vegetables, legumes with a *burghul* or bread base, are welcome anytime and anywhere: in mezzes (appetizers), elegant lunches and family meals.

As a general rule, olive oil, lemon, garlic and seasonings are the basic ingredients for salad dressings. Chopped parsley and green onions are dominant as garnishings.

The lettuce most commonly used is the romaine variety. Butterhead is another variety that is available. Curly endive and Belgian endive, watercress, spinach, dandelion greens, beettops and cabbage, must all be fresh and perky. All greens must be stored in airtight containers in the refrigerator. Wash the greens under cold running water several hours before using them. Pat them dry in a towel and refrigerate them again, wrapped in a towel. The dressing must be poured on just before serving.

Main dish salads made of cooked vegetables or legumes are a favorite way of serving these important protein and vitamin rich foods. As a general rule, vegetables must not be overcooked. Legumes must be soaked overnight and cooked until just tender, not soft and pulpy. The dressing is best absorbed if added when the vegetables are still hot. It usually consists of lemon, olive oil, garlic and such spices and herbs as cumin, fresh coriander, parsley, mint and onions.

Mixed Salad with Tahini Dressing

salaṭa makhlūṭa bi-ṭaḥīni

2 cucumber pickles, chopped
1 bunch radishes, chopped
2 medium tomatoes, seeded and chopped
5 small cucumbers, chopped
2 tablespoons chopped fresh mint leaves
2 tablespoons lemon juice
1 tablespoon olive oil
2 tablespoons tahini
salt and pepper

Mix the vegetables together in a salad bowl. Blend the *tahini* with lemon juice, oil and one tablespoon of cold water. Season with salt and pepper and pour the dressing over the vegetables. Blend well, chill and serve. Serves 4-6.

Watercress Salad

salaṭit rashād

3 bunches watercress
3 tablespoons olive oil
2 tablespoons lemon juice
1 clove garlic, crushed
½ teaspoon Dijon or hot mustard
salt and pepper

Remove the roots of the watercress, wash and cut in three. Remove to a colander to drain well. Prepare the dressing by mixing the mustard and lemon with the oil, garlic and seasoning. Mix well with a wire whisk. Just before serving, place the watercress in a salad bowl and pour the dressing over it. Toss and serve. Serves 4.

Radish Salad

salaṭit fijl

5 long white radishes, sliced thin
1 onion, sliced thin
1 clove garlic, crushed
2 tablespoons olive oil
1 tablespoon lemon
½ teaspoon salt

Place the slices of radish and onion in a shallow bowl. Prepare the dressing of lemon, garlic and seasoning, and pour it over the slices. Toss and serve. Serves 4.

Eggplant Salad

rās al-iṭṭa

2 large eggplants
1 tomato, chopped
1 green pepper, chopped
1 hot, green or red chili pepper, chopped
1 small onion, chopped (or 4 spring onions)
2 tablespoons pomegranate molasses
2 tablespoons olive oil
1 tablespoon lemon juice
1 clove garlic, crushed
salt and pepper

For garnishing:

10 black olives, pitted
1 tablespoon of chopped fresh mint leaves
1 tablespoon chopped parsley

Grill the eggplants over charcoal or in a very hot oven until the skin is blistered and the flesh is soft and juicy. Remove the skin under cold running water, seed, and squeeze out the juice.

In a mixing bowl, mash the eggplant lightly with a fork. Add the chopped tomato, onions, green pepper and chili pepper, and mix.

Prepare the pomegranate dressing by mixing the pomegranate molasses, oil, lemon juice, garlic and seasoning. Pour the dressing over the eggplant mixture and mix well. Place it in a serving bowl and garnish with mint leaves, parsley and black olives. Serves 4-6.

Variation

The eggplant may be used raw. Simply peel, chop and place them in a colander. Sprinkle one teaspoon of salt and set aside for ½ hour to drain the bitter juices. Squeeze the water out gently before using the eggplant in the salad. Proceed as above.

Puréed Eggplant Salad

salaṭit bātinjān

2 pounds large eggplant
2 stale bread rolls or one loaf stale flat bread,
 broken into croutons
1 cup coarsely chopped parsley
1 cup chopped spring onions
3 cloves garlic, crushed
1 teaspoon salt
½ teaspoon pepper
½ cup lemon juice
⅔ cup olive oil
one chili pepper, chopped

Pierce the eggplant with a fork to allow the steam to escape. Grill in a hot oven or over charcoal until the skin blisters. Remove the skin under running cold water and dry on absorbent paper. Purée and add the bread.

Mix the parsley, onions, chili pepper, lemon juice and oil. Season with salt and pepper and add the mixture to the eggplant. Blend well and serve. Serves 4–6.

Lemon Salad

salaṭit ḥāmuḍ

3 lemons, peeled, pitted and chopped
½ cup green olives, pitted and split in half
½ cup black olives, pitted and split in half
½ teaspoon cumin
½ cup chopped fresh parsley
1 tablespoon olive oil
salt and pepper to taste

Mix the chopped lemon, olives and parsley
with the oil and seasoning. Remove to a
deep bowl and serve with flat Arabic bread.
Serves 4.

Garden Rocket Salad

salaṭit rocca (jarjīr)

1 pound garden rocket
½ cup olive oil
¼ cup lemon juice
2 cloves garlic, crushed
1 teaspoon dry mustard seeds
salt and pepper

Wash the garden rocket well under cold running water and drain in a colander. Remove the stalks and set aside in a salad bowl. Mix the lemon juice, olive oil, garlic, mustard seeds, and season with salt and pepper. Pour the dressing on the greens, toss and serve. Serves 4.

Beet and Laban Salad

salaṭit shmandar bi-laban

2 beets, boiled and mashed
2 tablespoons labneh (page 43)
1½ cups laban
2 cloves garlic, crushed
salt and pepper to taste
fresh mint leaves for garnishing

Blend the mashed beets, *labneh*, *laban* and garlic into a smooth creamy sauce. Season with salt and pepper to taste. Serve the mixture in a deep bowl garnished with dots of *labneh* and fresh mint leaves. The sweet and sour flavor combination is excellent and the deep pink of the salad adds color to a table. Serves 4.

Beets in Tahini

khlāṭ

2 beets
½ cup tahini
½ cup lemon juice
2 cloves garlic, crushed
1 cup laban
salt to taste

Boil and peel the beets. Grate and set them aside. Prepare the *tahini* dressing by mixing the crushed garlic, lemon juice, salt and enough water to give it a creamy consistency. Add the *laban* and blend well. Fold in the grated beets and correct the seasoning. If the mixture is too thick add a little water and lemon juice. Serves 4.

Kidney Bean Salad

salaṭit fāṣūliya ḥamrā

1 cup dried kidney beans, soaked overnight
1 green pepper, chopped
2 tablespoons chopped spring onions
1 tablespoon chopped parsley
2 tablespoons olive oil
2 tablespoons lemon juice
salt and pepper

Cook the kidney beans in water until tender. Drain and place in a salad bowl lined with leaves of lettuce. Garnish with the chopped green peppers, onions and parsley. Prepare the dressing of lemon juice, oil and seasoning, and pour it over the kidney beans. Serves 4.

Variation

Use the same dressing described above and substitute white navy beans for the kidney beans, and chopped parsley for the green peppers.

Mixed Bean Salad

salaṭit fāṣūliya mshakkaleh

½ cup dried navy beans, soaked overnight
½ cup dried kidney beans, soaked overnight
½ cup dried chickpeas, soaked overnight
2 cups green beans, lightly cooked
1 green pepper, chopped
1 red pepper, chopped
3 celery stalks, chopped
1 medium onion, finely chopped or ½ cup
 chopped green onions
½ cup vinegar
¼ cup lemon juice
¾ cup olive oil
3 cloves garlic, crushed
1 teaspoon salt
black pepper
1 teaspoon sugar
½ cup chopped parsley

Drain and cook the beans and peas separately until tender – about 1-2 hours each. Remove to a mixing bowl. Mix the dressing of vinegar, lemon juice, garlic, sugar, salt and pepper, and pour it over the beans while still hot. Mix well and add the green beans, peppers and parsley. Cover and refrigerate before serving. Serves 6.

Dried Navy Bean Salad

salaṭit fāṣūliya baydā

1 cup dried navy beans, or small white beans,
 soaked overnight
½ cup olive oil
¼ cup lemon juice
2 hard-boiled eggs, sliced
5 black olives, pitted and halved
1 tomato, sliced
salt and pepper

Boil the beans until tender but firm. Drain
in a colander and while hot, add the
dressing of oil, lemon and seasoning. Mix
well and add the eggs and black olives.
Garnish with tomato slices. Serve with flat
bread. Serves 4.

Cucumber and Laban Salad

salaṭit khiyār bi-laban

2 cups laban
3 cucumbers
1 teaspoon salt
2 cloves garlic, crushed
1 teaspoon dried mint leaves

Beat the *laban* until smooth. If it is too thick,
add a little water to thin it. Blend in the
garlic. Peel and slice the cucumbers and add
them to the *laban* and garlic mixture. Season
with salt and mix well. Serve in a salad
bowl sprinkled with dried mint leaves.
Serves 4.

Cucumber and laban salad

Cucumber and Walnut Salad

salaṭit khiyār bi-jawz

3 small cucumbers
½ cup shelled walnuts
½ loaf French bread
3 tablespoons lemon juice
1 teaspoon red chili pepper

Peel and slice the cucumbers in rounds. Remove the pulp from the French bread and soak it in water. Crush the walnuts in a mortar with a pestle or blend in a blender with the soaked bread pulp, lemon juice and half the hot pepper until the sauce is of a thick creamy consistency. Pour over the cucumbers and sprinkle with remaining hot chili pepper. Serves 4.

Fresh Wax Bean Salad

salaṭit fāṣūliya 'arīda

1 pound fresh yellow wax beans
2 cloves garlic, crushed
½ cup chopped parsley
1 small onion, chopped
3 tablespoons olive oil
1 lemon, peeled, pitted and chopped
salt and pepper to taste

Boil the beans in salted water until tender. Drain and place them in a deep bowl. When cool, add the parsley, lemon and onion. Mix the garlic with the oil, season with salt and pepper, and pour the dressing over the mixture. Mix well and serve. Serves 4.

Cabbage Salad

salaṭit malfūf

3 cups shredded cabbage
2 tablespoons oil
2 tablespoons lemon juice
1 clove garlic, crushed
salt and black pepper

Keep the shredded cabbage in cold water
while you prepare the lemon dressing. Just
before serving, pour the dressing over the
drained cabbage in a deep salad bowl. Toss
and serve. Serves 4.

Cabbage and Beet Salad

salaṭit malfūf wa shmandar

1 pound beets
2 cups shredded cabbage
2 tablespoons lemon juice
3 tablespoons olive oil
1 clove garlic, crushed
1 tablespoon chopped parsley
salt and pepper

Wash and boil the beets in water, peel and
slice it into rounds. Prepare the lemon and
oil dressing separately. In a large salad bowl
place the cabbage, add the sliced beets and
pour on the dressing. Garnish the salad
with chopped parsley. Serves 4.

Mixed Salad

salaṭa 'arabiyyeh

1 lettuce, shredded
3 small cucumbers, diced
3 tomatoes, diced
5 green onions, chopped
5 radishes, diced
1 bunch parsley, coarsely chopped
½ bunch fresh mint leaves, coarsely chopped
2 cloves garlic, crushed
3 tablespoons olive oil
2 tablespoons lemon juice
salt and pepper

Wash the ingredients well and then proceed
to dice, shred and chop as indicated above.
Prepare the dressing of lemon, oil, garlic,
salt and pepper. Pour over the salad. Toss
and serve. Serves 4-6.

Thyme Salad

Thyme Salad

salaṭit za'tar

3 cups fresh thyme leaves
1 small onion, thinly sliced into rings, or
 ½ cup chopped spring onions
2 tablespoons pomegranate molasses
¼ cup olive oil
2 cloves garlic, crushed
salt
1 tablespoon lemon juice

Wash the thyme leaves and set aside in a colander to drain.

Prepare the dressing by mixing the pomegranate molasses with oil, garlic and lemon juice. Blend well and season with salt to taste.

In a shallow bowl arrange the onion rings or chopped spring onions on the thyme leaves, and pour on the dressing. Serves 4.

Thyme and Lemon Salad

salaṭit za'ar wa ḥāmuḍ

3 cups fresh thyme leaves
1 small onion, chopped
1 lemon, peeled and chopped
¼ cup olive oil
salt and pepper
black olives

Wash the thyme leaves and drain in a colander. When dry, place in a bowl and add the chopped lemon and onion. Mix lightly and sprinkle the olive oil dressing. Garnish with black olives. Serves 4.

Tomato Salad

salaṭit banadūra

5 medium tomatoes, sliced and seeded
1 medium onion, thinly sliced into rings
2 cloves garlic, crushed
½ cup olive oil
salt and pepper
2 tablespoons chopped parsley

Prepare the dressing separately by mixing the oil with the garlic, salt and pepper. In a shallow dish place the tomato and onion slices, and pour the oil dressing over them. Sprinkle the chopped parsley and serve with hot Arabic bread. Serves 4.

Dandelion Greens Salad

salaṭit hindbeh

2 pounds tender fresh dandelion greens
½ cup lemon juice
½ cup olive oil
1 clove garlic
½ teaspoon Dijon mustard
salt and pepper

Clean the dandelion greens, remove the yellowed leaves, and wash in the colander under running cold water several times to remove all traces of soil. Cut in three and return to a colander to drain.

Prepare the dressing by mixing the mustard, oil, lemon, garlic, salt and pepper. Pour the dressing over the dandelion greens. Serves 4.

Mixed Herbs and Burghul Salad

tabbūleh

¼ cup burghul
2 medium-sized tomatoes, peeled, seeded and chopped
4 cups very coarsely chopped parsley
½ cup chopped spring onions
1 cup coarsely chopped fresh mint leaves
¾ cup olive oil
½ cup lemon juice
salt and bhar
crisp lettuce, cabbage or vine leaves

In a large mixing bowl, rub the *burghul* with onions, add the parsley and mint, and toss gently. Prepare the dressing by mixing the lemon, salt, oil with the seasoning of salt and pepper. Pour the dressing over the herb mixture. Stir in the tomatoes gently. Serve in a salad bowl lined with lettuce, cabbage or vine leaves. Serves 4-6.

Tomato Salad with Walnut Sauce

salaṭit banadūra wa jawz

3 medium tomatoes, seeded and coarsely
 chopped
1 medium green pepper, coarsely chopped
½ bunch spring onions, chopped
¼ cup shelled walnuts
½ cup coarsely chopped fresh mint leaves
4 tablespoons olive oil
½ cup lemon juice
½ cup seeded black or green olives
2 slices stale white bread, crust removed
salt and pepper to taste

Grind the walnuts in a mortar with a pestle,
or use a food processor, adding lemon juice
gradually. Soak the bread in water, squeeze,
crumble and add it to the walnuts and oil.
Blend well. Pour the walnut dressing over
the tomatoes, onions and green peppers.
Add the mint leaves, season with salt and
pepper, and serve in a round bowl. Garnish
with the olives. Serves 4.

Potato Salad

salaṭit baṭāṭa

4 medium potatoes, boiled
2 cloves garlic, crushed
1 teaspoon salt
½ teaspoon freshly ground black pepper
2 tablespoons olive oil
1 lemon, squeezed
1 tablespoon chopped parsley
1 tablespoon chopped onion

Peel and slice the potatoes into one-inch
pieces and put them in a mixing bowl. Add
the parsley and onion and mix well. Prepare
the dressing of lemon, olive oil, garlic and
seasoning, and pour it over the warm
potatoes. Chill and serve. Serves 4-6.

Cooked Vegetable Salad

salaṭit khudra maslū'a

2 medium zucchini
3 medium potatoes
4 beets
1 cup fresh green beans
3 hard-boiled eggs
½ cup olive oil
2 tablespoons lemon juice
3 cloves garlic, crushed
1 teaspoon salt
½ teaspoon pepper
1 tablespoon chopped fresh mint leaves

Boil the four vegetables separately until
tender but firm. Chop and place them in a
mixing bowl. Chop and add the hard-boiled
eggs. Mix the olive oil, lemon, garlic and
seasoning. Pour the dressing over the
vegetables in the mixing bowl. Sprinkle with
mint leaves and serve. Serves 4.

Fresh Broad Bean Salad

salaṭit fūl akhḍar

1 pound fresh broad beans or fava beans,
 topped, tailed and stringed
4 cloves garlic, crushed
2 tablespoons olive oil
1 tablespoon lemon juice
½ teaspoon salt
½ teaspoon cumin
2 tablespoons chopped spring onions
2 tablespoons chopped parsley

Wash and boil the beans until tender. Drain well, season with salt and pepper, and garnish with parsley and onions. Prepare the dressing of oil, garlic, lemon juice and seasoning, and pour it over the beans. Serves 4.

Bread Salad

fattūsh

1 loaf stale flat Arabic bread
4 leaves lettuce, shredded
½ cup coarsely chopped onions
½ cup coarsely chopped spring onions
1 cup coarsely chopped cucumbers
2 cups coarsely chopped tomatoes
1 bunch fresh mint leaves, chopped
1 bunch fresh parsley, coarsely chopped
2 cloves garlic, crushed
½ cup lemon juice
⅔ cup olive oil
2½ teaspoons salt
½ teaspoon pepper
1 tablespoon sumac
2 tablespoons oil

Break the bread into croutons, fry in 2 tablespoons oil and remove to absorbent paper to drain away the excess oil; the bread may be toasted if preferred. In a large mixing bowl, mix the chopped vegetables and herbs. Add the bread croutons. Prepare the dressing of lemon juice, oil, garlic, and seasoning, and pour it over the mixture. Correct the seasoning adding more lemon juice if required. Toss and serve in a large salad bowl. Serves 4-6.

fattush

Sauces

The Lebanese use only a few main sauces, usually based on one individual herb, nut or spice such as garlic or sesame paste or pine nut paste. Unlike the Europeans, who mix their sauces with their food, the Lebanese use their sauces as accompaniment to vegetables or on their own as dips.

Garlic Sauce

ṣalṣit tūm

10 cloves garlic, crushed
1½ cups olive oil
1 tablespoon lemon juice
1 2-inch slice of French white bread,
 crust removed
salt to taste

Soak the bread in cold water, squeeze, dry and crumble it into a bowl.

Using a mortar and pestle, or a food processor, crush the garlic with the salt. Add the lemon juice and oil gradually until the garlic is smooth. Blend in the breadcrumbs, adding oil or lemon when necessary, until the sauce is of a thick creamy consistency. Do not overbeat to prevent curdling.

Spicy Walnut Sauce

mḥammarah

1 pound walnuts, finely ground
2 tablespoons breadcrumbs
1 bread roll, soaked in water
2 tablespoons olive oil
2 tablespoons grape or carob molasses
2 tablespoons lemon juice
1 teaspoon red hot chili pepper
1 teaspoon caraway seeds
1 teaspoon salt

Using a food processor, blend all the above ingredients well and add a little water. Continue blending until the sauce becomes smooth and thick. Serve with flat Arabic bread.

Eggplant Dip

mtabbal – bābā ghannūj

2 medium eggplant
½ cup lemon juice
1-2 tablespoons tahini
1 clove garlic
½ teaspoon salt
2 tablespoons chopped parsley
1 tablespoon olive oil
¼ cup sour pomegranate seeds (optional)

Pierce the eggplant with a fork, grill in a hot oven until the skin blisters. Remove the skin under cold running water. Seed and mash them well. Blend in the lemon juice and *tahini* diluted in water. Add salt and garlic. Beat vigorously stirring in more water if the mixture is too thick. Correct the seasoning and pour into a bowl. Sprinkle olive oil and garnish with parsley and sour pomegranate seeds. Serve with flat Arabic bread. Serves 4-6.

Eggplant Ratatouille

ālib bātinjān

2 pounds medium eggplant, sliced in rounds
 and salted
2 large onions, sliced in rounds
3 medium tomatoes, skinned and sliced
2 large green peppers, seeded and sliced
1 bunch fresh mint leaves
12 cloves garlic, peeled
2 cups oil
½ cup tomato juice

Heat the oil and sauté the eggplant slices until lightly browned but firm. Remove to absorbent paper to drain.

In a heavy-based pan, place the tomatoes, peppers, garlic and onion rounds in layers. Top with eggplant slices and add fresh mint leaves. Season with salt and pepper. Continue the layers of pepper, tomatoes and eggplant. Pour on the tomato juice and bring to the boil.

Reduce the heat and simmer for 45 minutes, until the sauce is reduced.

Serve cold. Serves 4-6.

bābā ghannūj

Stuffed Eggplant

bātinjān imām bayildi

10 long small eggplants
6 medium tomatoes, skinned, seeded
 and chopped
5 cloves garlic, chopped
3 medium onions, chopped
1 fresh bunch of parsley, chopped
2 tablespoons lemon juice
a pinch of sugar
½ cup olive oil
salt and pepper to taste

Peel the eggplant skin leaving alternate strips of skin and flesh. Split open, sprinkle with salt, and set aside in a colander to drain the bitter juices.

Prepare the tomato and onion mixture by sautéeing the onion in oil until transparent. Add the tomatoes, garlic, parsley and seasoning. Cook for 5 minutes on low heat. Season with salt and pepper.

Heat the remaining oil in a heavy pan and sauté the eggplant over high heat until lightly browned but firm. Remove and fill with the tomato mixture. Sprinkle lemon juice and sugar, and add ½ cup of water. Cover the pan and simmer for 45 minutes on very low heat, adding water only if necessary. May be served cold or warm. Serves 4-6.

Eggplant in Laban Sauce

fattet bātinjān

2 large eggplants
4 medium tomatoes, skinned and sliced
2 onions, sliced
3 tablespoons butter
4 cloves garlic, crushed
½ cup pine nuts
2 cups laban
2 tablespoons tahini
1 loaf flat Arabic bread
1 cup oil
1 teaspoon crushed dried mint leaves
salt and pepper
1 bunch fresh parsley, chopped

Peel and cut the eggplants lengthwise into ½-inch thick slices. Sprinkle with salt and set aside to drain the bitter juices – about ½ hour.

Rinse and dry the eggplant slices and fry them in oil until golden. Remove to absorbent paper to drain.

In a mixing bowl, beat the *laban* until smooth. Add half the crushed garlic and the mint leaves and blend well. Season with salt and pepper to taste and set aside.

Sauté the onions and the remaining crushed garlic in one tablespoon of butter until the onions are transparent. Add the tomatoes and parsley. Season and simmer on low heat until the tomatoes are cooked and the liquid is reduced.

Fry the bread in hot oil, break it into croutons, and set aside on absorbent paper to drain.

Line a deep serving dish with half the croutons. Add the eggplant slices and cover with tomato sauce and the remaining croutons.

Just before serving, sauté the pine nuts in the remaining butter. Pour the *laban* sauce over the eggplant and top with the hot butter and nuts. Serve immediately. Serves 4-6.

Stuffed Eggplants, Cucumbers and Peppers

meḥshī bātinjān wa khiyār wa flayfleh ṣiyāmī

2 pounds small well-formed cucumbers
2 pounds small long eggplants
1 pound sweet green peppers
1 pound tomatoes, skinned and chopped
1½ cups uncooked rice
3 bunches parsley, chopped
½ bunch fresh mint leaves, chopped
1 onion, chopped
1 cup olive oil
1 tablespoon sumac
1 lemon, juiced
1 tablespoon pomegranate molasses
1½ teaspoons salt
¼ teaspoon allspice or bhar

Wash the eggplants and cucumbers well. Do not peel. With a sharp knife, cut across at the narrow part of each eggplant and cucumber below the top, and proceed to remove the inside pulp, using a special corer or a small spoon. Do not break the outer skin of the vegetables. Sprinkle the eggplants with salt and place in a colander for ½ hour to drain the bitter juices. Empty the green peppers of their seeds leaving them whole.

Meanwhile, mix the rice with the tomatoes, parsley, mint leaves and onion, and season with salt and *bhar*. Add lemon, sumac and pomegranate molasses, and mix well. Stuff each empty eggplant, cucumber and pepper ¾ full with the rice mixture. Lay them close together in layers in a pot. Add a little water and bring to the boil over high heat. Reduce the heat and simmer for 1¼ hours or until the vegetables are tender and the rice is done. Serve at room temperature. Serves 6.

Tomato and Garlic Dip

ti'liyet banadūra

8 tomatoes, skinned, seeded and sliced
* in rounds*
15 cloves garlic, chopped
1 onion, chopped
¼ teaspoon cinnamon
1 tablespoon chopped parsley
2 tablespoons olive oil
pepper to taste
¼ teaspoon salt

Heat the oil in a heavy nonstick pan. Sauté the onions until transparent. Add the tomatoes, garlic, cinnamon and seasoning. Cover and cook over very low heat until done. Garnish with chopped parsley and serve cold. Serves 4.

Variation

Tomato with Garlic and Coriander

ti'liyet banadūra bi-kuzbra

2 pounds tomatoes, skinned and chopped
1 bunch fresh coriander, chopped
½ cup olive oil
7 cloves garlic
salt and pepper to taste

Crush the garlic with the coriander in a mortar with a pestle.

Heat the oil in a pan and sauté the mixture for 2 minutes. Add the tomatoes and mix well. Cook over very low heat for 15 minutes.

Cover and simmer for 3 minutes longer or until the tomatoes are pulpy. This dish is best when served cold with flat Arabic bread. Serves 4-6.

Green Pepper and Tomato Ratatouille

msa'a'et banadūra wa flayfleh

3 green peppers, seeded and sliced
4 tomatoes, skinned and sliced
3 tablespoons oil
2 cloves garlic, chopped
2 tablespoons chopped parsley
salt and pepper

Sauté the green pepper slices in hot oil – about 10 minutes. Fold in the tomatoes and season with salt and pepper. Cook for 5 minutes until the vegetables are soft and tender. Do not allow the tomatoes to become pulpy. In a separate pan, sauté the garlic in one tablespoon oil, add the chopped parsley, and mix well. Add the mixture to the peppers and tomatoes and toss for 2 minutes. This appetizer may be served cold or hot on toast, or in a flat serving dish. Serves 4.

Okra with Sour Pomegranate Juice

bāmiyeh bi-rubb rummān

1 pound okra
½ cup sour fresh pomegranate juice or
　1 tablespoon pomegranate molasses
½ cup olive oil
3 cloves garlic, crushed
1 bunch coriander, chopped

Wash and top the okra. Place it on a towel to dry. Meanwhile, mix the pomegranate juice, garlic and salt, and set aside.
　Heat the olive oil and sauté the okra until browned. Remove to absorbent paper to drain. Sauté the coriander in the oil, add it to the okra, and pour on the pomegranate dressing. Set aside for 30 minutes before serving at room temperature. Serves 4.

Okra with Tomatoes in Olive Oil

bāmiyeh bi-zayt

2 pounds fresh okra
2 large onions, sliced or 10 very small onions
⅓ cup olive oil
4 tomatoes, skinned, seeded and sliced
4 cloves garlic
1 tablespoon tomato paste, diluted
½ cup chopped fresh coriander leaves
salt and pepper
¼ cup lemon juice

Wash and top the okra. Drain and dry well. Sauté the onions in oil until golden. Add the garlic and okra, season and sauté until the okra is browned. Add the tomato slices and tomato paste and simmer in their own juices for 15 minutes on very low heat. Uncover and add coriander and lemon juice. Simmer 10 minutes until done. Serve warm or cold. Serves 4-6.

Fresh Broad Beans in Laban

fūl akhḍar bi-laban

2½ pounds fresh broad beans or
 fava beans, shelled
2 cloves garlic, crushed
1 bunch fresh coriander, chopped
2 onions, sliced
2 cups laban
salt and pepper
¼ teaspoon cinnamon
½ cup olive oil

Cook the *laban*, see recipe for **Cooked Laban** page 43.

Heat half the oil and brown the onions and broad beans.

In a separate pan, sauté the garlic and coriander in the remaining oil and add to the *laban*. Add the onions and broad beans and simmer for 10 minutes, stirring continuously.

Serve it with rice and vermicelli (page 117). Serves 4-6.

Fresh Broad Beans with Swiss Chard

fūl akhḍar bi-sil'

2 pounds fresh broad beans or
 fava beans, shelled
2 pounds Swiss chard
4 cloves garlic
1 bunch fresh coriander, chopped
1 medium onion, chopped
½ cup olive oil
½ cup lemon juice
salt and pepper

Wash the Swiss chard and chop the stalks and leaves separately. Set aside in a colander to drain.

In a deep pot, brown the onions in oil until transparent. Add the beans and toss for 5 minutes. Add the chopped chard stalks and continue stirring until they soften. Season with salt and pepper and add the leaves. Add water to cover and simmer for 40 minutes.

Meanwhile, crush the garlic with salt and coriander and add them to the cooking pot. Simmer until all the liquid is reduced. Add lemon juice and serve at room temperature with spring onions. Serves 4-6.

Fresh Broad Beans with Lemon Dressing

fūl akhḍar mtabbal

2 pounds fresh broad beans or
 fava beans, shelled
½ cup olive oil
¼ cup lemon juice
2 cloves garlic, crushed
½ teaspoon salt
¼ teaspoon allspice or bhar
¼ teaspoon red chili pepper

Wash the broad beans and set aside to drain in a colander. Cook them for 10 minutes in boiling water until done. Drain and set aside.

Prepare the dressing by blending the lemon juice, oil, garlic and seasoning.

While the broad beans are still warm, pour on the lemon dressing. Sprinkle red chili pepper and serve with flat Arabic bread. Serves 4-6.

Fresh Broad Beans with Coriander

fūl akhḍar m' allā

2 cups fresh broad beans or fava beans, shelled
3 cloves garlic, crushed
1 bunch fresh coriander, chopped
1 tablespoon butter
1 cup laban, lightly beaten
½ teaspoon salt
¼ teaspoon pepper
¼ teaspoon cumin

Cook the broad beans in very little water until just tender.

In a pan, melt the butter and sauté the garlic and coriander. Add the beans and sauté for a few minutes longer.

Season with salt, pepper and cumin, and remove from the heat. Pour the *laban* over the mixture. Serve immediately with flat Arabic bread. Serves 4-6.

Green Beans in Olive Oil

lūbiyeh bi-zayt

1 pound fresh green beans
2 medium onions
⅓ cup olive oil
4 medium tomatoes, skinned
4 cloves garlic
1½ teaspoons salt
½ teaspoon allspice or bhar
1 teaspoon tomato paste, diluted in
 a little water

Top, tail and string the beans and wash them well in cold water.

Chop the onions and garlic and sauté them in oil until golden. Add the vegetables, salt and allspice or *bhar* and toss lightly. Cover and cook for 10 minutes over very low heat. Add the tomato paste. Slice the tomatoes and fold in. Simmer in their own juices for 15-20 minutes, until the gravy thickens.

The beans are equally good served cold or warm. Serves 4.

Green Beans with Sour Pomegranate Juice

lūbiyeh bi-rubb rummān

1 pound green beans, topped and tailed
1 clove garlic, crushed
½ cup fresh sour pomegrante juice or
 1 tablespoon pomegranate molasses
½ cup olive oil
1 tablespoon chopped parsley
salt to taste

Cook the beans on very low heat with very little water until tender; do not overcook. Remove and cover in cold water to keep firm. Meanwhile, mix the pomegranate juice with oil and garlic and season with salt. Drain the beans well and pour on the dressing. Garnish with chopped parsley and serve cold. Serves 4.

Sautéed Zucchini with Tomato Sauce

kūsā ma' ti'liyet banadū'ra

2 pounds zucchini, sliced into rounds
2 eggs
1 small onion, finely chopped
1 cup flour, mixed with cold water into a paste
2 cloves garlic, finely chopped
½ cup olive oil
¼ cup chopped mint leaves
salt and pepper to taste

Heat the olive oil and sauté the zucchini until half done. Remove to absorbent paper to drain. Meanwhile, beat the eggs well and fold in the flour, garlic, onions and mint. Season with salt and pepper to taste. Dip the zucchini rounds in the egg mixture and spoon into the hot oil and brown a second time. Remove to a serving dish and line it with the rounds, leaving the center empty.

Prepare the Tomato Sauce or *Ti'liyet al-Banadūra*

2 onions, sliced
3 red tomatoes, skinned and chopped
¼ cup olive oil
¼ cup chopped fresh mint leaves
1 teaspoon hot chili sauce
salt and pepper to taste

Heat the oil and brown the onions, and add the chopped tomatoes, hot chili sauce and mint leaves. Simmer until the liquid is reduced. Spoon the thick sauce into the center of the serving dish lined with the zucchini. Serve at room temperature. Serves 4-6.

Popovers of Zucchini Pulp

'raṣ na'r al-kūsa

Zucchini pulp reserved from the coring of 12 small zucchini (see recipe for **Stuffed Zucchini** *page 87)*
1 small onion, chopped
3 cloves garlic, chopped
2 teaspoons chopped parsley
3 eggs
2 tablespoons flour
1 teaspoon salt
½ teaspoon pepper
1 tablespoon butter and 1 teaspoon oil

Boil the pulp in salted water for 10 minutes. Drain and press out the water. Combine the chopped onions, garlic and parsley and add them to the pulp. Mix well and fold in the eggs, flour, salt and pepper. Mix thoroughly and drop the mixture by the tablespoonful in deep hot fat. Fry until browned. Serve hot or at room temperature. Serves 4-6.

Baked Zucchini with Tahini

kūsā bi-ṭahíni

6 medium zucchini
½ cup chopped onions
½ cup chopped walnuts
¼ cup pine nuts
⅓ cup tahini
½ cup lemon juice
3 cloves garlic, crushed
3 tablespoons butter and oil
1 teaspoon salt
½ teaspoon allspice

Wash, scrape and slice the zucchini into rounds. Brown the slices in the butter and oil and remove to absorbent paper to drain. Sauté the onions and nuts lightly, and season with salt and allspice. Line the bottom of an ovenproof dish with one layer of zucchini rounds. Spread the nut mixture over them and top with the remaining zucchini.

Combine the *tahini*, lemon juice, crushed garlic, salt and blend well. Add water and beat well until the sauce is smooth and creamy. Pour the *tahini* sauce into the casserole and bake at 350° for 20 minutes. Serve with rice. Serves 4-6.

Purée of Zucchini

kūsā bi-dibs rummān

1 pound zucchini, sliced
1 loaf stale flat Arabic bread, broken
 into croutons
4 cloves garlic, crushed
1 medium onion, chopped
1 cup olive oil
2 tablespoons pomegranate molasses
½ teaspoon dried mint leaves
1 medium red or green chili pepper,
 finely chopped
salt and pepper

Cook the zucchini for 10 minutes in very little water. Add the croutons of bread, continue cooking for 10 minutes longer, or until the mixture becomes soft. Add the garlic, onions, peppers, pomegranate molasses and oil. Blend and season with salt and pepper and cook for 10 minutes. Serve with spring onions. Serves 4-6.

Stuffed Zucchini in Olive Oil

kūsā bi-zayt

12 medium zucchini, cored – reserve the
 pulp for other recipes
½ cup uncooked rice
½ bunch fresh mint leaves, chopped
2 bunches parsley, chopped
¼ cup chopped spring onions
½ cup olive oil
2 tomatoes, chopped
½ teaspoon allspice or bhar
½ cup lemon juice
2 tomatoes sliced into rounds

Combine the rice, chopped mint, parsley,
spring onions and tomatoes. Add the oil,
lemon and seasoning, and mix well. Stuff
the zucchini with the mixture ¾ full.
Arrange in a deep cooking pot layered with
tomato slices. Season and bring to the boil.
Reduce the heat and simmer 30 minutes or
until the zucchini is done. Unmold on a
shallow serving plate, adding more lemon
juice if necessary. Set aside to cool. Serves
4-6.

Variation

Follow the master recipe above, substituting
small eggplants for the zucchini.

Zucchini Pulp with Pomegranate Molasses

na'r kūsū bi-dibs rummān

the pulp from 2 pounds cored zucchini
1 onion, finely chopped
1 tablespoon pomegranate molasses
1 tablespoon oil
salt and pepper

Sauté the onions in the oil. Add the pulp
and reduce the heat. Season and cook for 15
minutes until the liquid is absorbed. Add
pomegranate molasses, mix well, and set
aside to cool. Serve at room temperature.
Serves 4.

Fried Zucchini with Laban

kūsā mi'li bi-laban

6 medium zucchini
1 cup laban
3 cloves garlic, crushed
2 tablespoons oil
salt to taste

Wash, scrape and slice the zucchini. Sauté
lightly in olive oil and remove to absorbent
paper to drain.
 Beat the *laban* well adding water to thin it.
Add crushed garlic and salt.
 Lay out the zucchini slices on a round flat
serving plate and top with the *laban*
dressing. Garnish with whole mint leaves
and serve. Serves 4.

Stuffed Zucchini

kūsā imām bayildi

Follow the recipe for **Stuffed Eggplant** on page 79, replacing the eggplant with zucchini, split open in the form of a cross.
 Once the cooking is done, add vinegar and serve.

Cauliflower with Coriander

arnabīt ma' kuzbra

1 head white cauliflower, separated into florets
1 cup olive oil
1 bunch fresh coriander, chopped
4 cloves garlic, crushed
salt and pepper
1 cup water
juice of 1 lemon

Wash and drain the cauliflower. Sauté in oil and remove to absorbent paper to drain the excess fat. Mix the garlic with the coriander and season. Add to the cauliflower and pour in the water. Cook until done – about 10 minutes. Sprinkle with lemon juice before serving. Serve with rice on the side.
Serves 4-6.

Sautéed Cauliflower Patties

arnabīṭ 'rāṣ

2 pounds cauliflower, separated into florets
1 small onion, chopped
1 clove garlic, chopped
1 tablespoon chopped parsley
1 tablespoon chopped fresh mint leaves
2 eggs
½ cup milk
½ cup flour
1 teaspoon baking powder
vegetable oil for frying

Clean and partially cook the cauliflower in water. Season with salt and pepper to taste. Mix the onion, garlic, parsley and mint leaves with the egg yolks and season with salt and pepper. Beat the mixture well with a fork until it thickens. Add milk and blend in the flour and baking powder. Dip the cauliflower florets into the soft dough and coat well. Spoon into hot frying oil. Brown well on both sides. Remove to absorbent paper. Serve hot or cold. Garnish with lemon wedges. Serves 4-6.

Variation

Sautéed Zucchini Patties

Follow the master recipe above, substituting 2 pounds zucchini for the cauliflower.

Artichoke Hearts Stuffed with Herbs

meḥshī arḍishawki

10 artichokes
1 lemon, squeezed
1 lemon, quartered
2 tomatoes, finely chopped
1 cup chopped parsley
½ cup chopped mint leaves
½ cup chopped spring onions
1 tablespoon olive oil
salt and pepper to taste
2 teaspoons flour mixed with cold
 water into a paste

Wash the artichokes well and stem them close to the base. Scoop out the choke and trim the base to form a cup. Drop the artichoke hearts in a large bowl of cold water to which lemon wedges and flour have been added, to prevent discoloring. Cook until tender. Drain, set aside and proceed to prepare the stuffing.

Mix all the herbs together and season with salt and pepper. Add oil, lemon juice and seasoning and toss well. Stuff the artichoke hearts with the mixture and serve. Serves 4.

Stuffed Artichoke Hearts

arḍishawki bi-zayt

16 large artichoke hearts
1 cup olive oil
16 small white onions
1 cup chopped carrots
1 cup fresh peas
½ teaspoon salt
¼ teaspoon pepper
1 tablespoon flour mixed with water
 into a paste
½ cup lemon juice

Prepare the artichoke hearts according to directions in the recipe page 89. Blend the flour with the olive oil and add boiling water. Drop the artichoke hearts and onions into the water and season. Cook until the vegetables are tender and the sauce is reduced.

Meanwhile, chop and boil the fresh carrots with the peas in salted water until tender. Fold over the cooked artichoke hearts. Add the lemon juice and simmer for 2-3 minutes.

To serve, arrange the hearts on a serving dish and fill with the vegetables. Top with the thickened sauce. Set aside to cool. The dish is best served cold. Serves 6-8.

Jew's Mallow in Oil

mlūkhiyyeh bi-zayt

4 pounds fresh mlūkhiyyeh (see glossary)
1 onion, sliced
5 cloves garlic, crushed
1 bunch fresh coriander, chopped
1 teaspoon salt
pinch of cinnamon
¼ cup oil
2 lemons, squeezed

Strip the leaves from the stalks of the *mlūkhiyyeh* and wash well. Brown the onions and garlic in oil. Chop and add the *mlūkhiyyeh* and toss. Season with salt and cinnamon. Add the coriander and lemon juice, toss for a few minutes and remove to a side dish. Serve cold with Arabic bread. Serves 4-6.

Swiss Chard with Lentils and Sumac

'adas bi-sil'

¾ cup lentils
*1 pound Swiss chard stalks, (use the leaves
 for recipe below).*
2 tablespoons samneh
1 teaspoon sumac
1 onion, finely chopped
3 cloves garlic, crushed
*1 teaspoon flour, mixed with cold water
 into a paste*
1 lemon, juiced
salt and pepper to taste
½ teaspoon ground cumin

Wash and boil the lentils until done. Heat
the *samneh* and sauté the onion until
browned. Dissolve the flour paste in one
cup of hot water and add to the lentils and
stir.

 Meanwhile, wash and slice the chard
stalks into 1-inch pieces and bring to the
boil for 10 minutes or until tender. Add the
stalks to the pot of lentils with garlic, sumac
and lemon juice. Season with salt and
pepper and simmer until the soup thickens.
Blend the ground cumin into the soup and
serve hot. Serves 4.

Swiss Chard Leaves in Olive Oil

sil'bi-zayt

4 pounds fresh Swiss chard leaves
2 large onions, chopped
½ cup olive oil
¼ cup lemon juice
3 cloves garlic, crushed
salt to taste

Clean, remove the stalks, and wash the
chard. Remove to a colander to drain.
Reserve the stalks for recipe below. Chop
the chard leaves finely and set aside.

 Brown the onions in oil and add the
chopped chard, garlic and salt. Cover and
cook well on low heat until all the juices are
absorbed. Serve sprinkled with lemon juice
and garnished with spring onions. Serves
4-6.

Chard Stalks with Tahini

ḍlūʿ bi-taḥīni

1 pound Swiss chard stalks separated from the
leaves which in turn are reserved for the
Stuffed Chard Leaves in Oil *recipe on
page 91*
2-3 cloves garlic, crushed
2 tablespoons lemon juice
4 tablespoons tahini
½ teaspoon salt

Cut the chard stalks into small pieces and
boil until tender. Blend the *tahini*, garlic,
lemon juice and salt, adding a few drops of
water to thin the *tahini*. Fold in the diced
chard stalks. Add more lemon juice, if
desired, and correct the seasoning. Serve as
a salad. Serves 4.

Variations

The chard stalks may also be boiled and
mashed and then folded into the *tahini*
dressing.

Swiss Chard Stalks in Laban

ḍlūʿ bi-laban

A *laban* dressing for chard stalks may be
substituted for the *tahini* dressing. Follow
the same steps given in the master recipe,
substituting *laban* for *tahini* and omitting the
lemon juice for water.

Swiss Chard Stalks with Lemon and Oil Dressing

ḍlūʿ bi-ḥāmuḍ

A simple lemon and oil dressing, with
crushed garlic and salt may be used for
diced chard stalks and is often preferred to
the heavier *tahini* dressing.

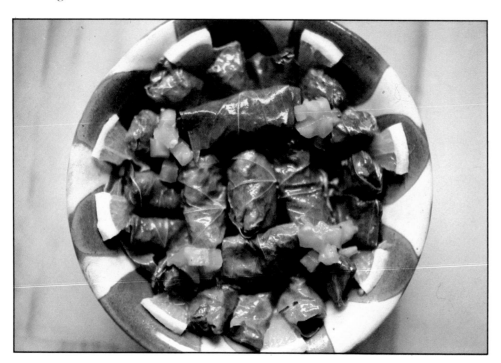

*Stuffed
vine leaves.*

Spinach in Laban

fattet sbēnekh

2 pounds spinach
2 medium onions, sliced
2 tablespoons butter
2 cups laban
2 cloves garlic, crushed
1 teaspoon dried mint leaves, crushed
½ cup pine nuts
salt and pepper to taste
1 loaf flat Arabic bread

Wash the spinach carefully and cut off the stalks leaving the leaves. In a pan, sauté the onions until transparent. Add the spinach, cover, and simmer in their own juices until cooked. In a bowl beat the *laban* with the garlic and season with salt and dried mint leaves.

Fry the bread in deep oil and set aside on absorbent paper to drain. Break into croutons.

In a separate pan, sauté the pine nuts in butter.

Just before serving, line the serving dish with one half of the croutons, top with spinach and onion mixture, and cover with *laban*. Add more croutons and sprinkle the pine nuts and hot butter. Serve immediately. Serves 4.

Stuffed Vine Leaves in Oil

meḥshī-wara' 'inab bi-zayt

1 pound fresh vine leaves (or canned)
1 cup uncooked rice
2 bunches parsley, chopped
½ cup dried chickpeas soaked overnight (optional)
2 tomatoes, chopped
½ cup olive oil
1 cup lemon juice
3-4 cloves of garlic
2 teaspoons salt
1 teaspoon allspice or bhar
1 onion, finely chopped

Pour hot water over the fresh vine leaves and set aside for 10 minutes. Press the soaked chickpeas under a rolling pin to remove the outer skin, cook them until tender.

Wash and drain the rice well. Combine the rice with the parsley, chickpeas, tomatoes, onions and garlic. Add oil, lemon, salt and allspice or *bhar* and mix well.

Place a helping of this filling on each vine leaf and roll into a finger shape. Arrange the individual finger rolls in rows in a deep cooking pot. Sprinkle with salt. Place on top of the stuffed leaves a round flat plate and press lightly to prevent the rolls from loosening while cooking. Add just enough water to cover the leaves. Cook over low heat for ½ hour. Simmer another hour.

Remove and add more lemon juice if necessary. Unmold on a round shallow platter and garnish with tomatoes and boiled potato slices. Serve at room temperature. Serves 6-8.

Variation
Stuffed Swiss Chard Leaves in Oil

meḥshī sil'

Follow the same recipe as above,
substituting 4 pounds fresh Swiss chard
leaves for the vine leaves. Remove the stalks
of the chard leaves and reserve them for the
Chard Stalks With Tahini page 92. Pour hot
water over the chard leaves and set aside
for a few minutes. Using the same filling as
in the master recipe given above, follow the
same method for rolling and cooking the
chard leaves.

Stuffed Cyclamen Leaves

meḥshī dwayk al-jabal

1 pound cyclamen leaves
2 small onions
½ cup crushed shelled walnuts
2 tablespoons pomegranate molasses
¼ cup lemon juice
½ teaspoon red chili pepper

Proceed as in the recipe for **Stuffed Vine Leaves** (see page 93), using the walnut stuffing instead. Serves 4-6.

Dandelion Greens in Olive Oil

hindbeh bi-zayt

4 pounds dandelion greens
4 large onions, sliced into rings
½ cup olive oil
1 teaspoon salt
6 cloves garlic
1 bunch fresh coriander, chopped
½ cup lemon juice

Wash, clean, stem and chop the dandelion greens. In a deep pot filled with boiling water, bring to the boil for 15 minutes. Meanwhile, brown the onions in oil. Remove to absorbent paper to drain.

When the dandelion greens are ready, drain and squeeze out excess water. Return them to the oil used to brown the onions, and add garlic and coriander. Sauté the mixture for 15 minutes or until done. Sprinkle with lemon juice. Garnish with the browned onions and serve. Serves 4-6.

Endives in Olive Oil

8 firm endives, quartered
2 onions, sliced
¼ cup olive oil
¼ cup lemon juice
salt and pepper

Bring the endives to the boil in salted water. Boil for 10 minutes or until tender. Drain well and set aside.

Meanwhile sauté the onions in oil until golden and add the endives. Cook on low heat for 10 minutes. Sprinkle with lemon juice, season and serve. Serves 4.

Mallow Stew

khubbayzeh bi-zayt

4 pounds mallow
2 large onions, chopped
½ cup olive oil
4 cloves garlic
salt and pepper to taste
½ cup water
¼ cup lemon juice
½ cup dried chickpeas, soaked overnight
 and cooked until tender

Clean the mallow and retain only the very
tender stalks. Chop the leaves and tender
stalks, and wash under cold running water
to remove all the traces of earth. In a heavy
cooking pot, brown the onions and the
chickpeas in oil. Add the mallow and garlic.
Pour in water, and season with salt and
pepper to taste. Cover and cook for 10
minutes or until the mallow is done and the
juices are reduced. Remove the mallow to a
serving dish and sprinkle with lemon juice.
Garnish with spring onions and serve.
Serves 4-6.

Gundelia in Olive Oil

'akkūb bi-zayt

6 pounds wild gundelia or 2 pounds
 cleaned stems
1 onion, finely chopped
½ cup olive oil
1 teaspoon salt
½ teaspoon bhar
3 lemons, squeezed
¼ cup chickpeas, soaked overnight

Cook the chickpeas in water. Clean the
gundelia removing the thistles and leaving
the inner tender stems. Heat the oil and
sauté the onions and chickpeas. Add the
gundelia, season, and simmer on low heat
for 35 minutes. Add lemon juice and serve
at room temperature. Serves 4.

Gundelia and Whole Wheat

'akkūb bi-amḥ

6 pounds gundelia, or 2 pounds cleaned stems
1 cup whole wheat
1 teaspoon salt
½ teaspoon cinnamon
½ teaspooon pepper
2 cups of water

Clean the gundelia well removing the thistle and leaving the inner tender stems. Bring the water to the boil in a deep pot. Add the gundelia and whole wheat. Season with salt, pepper and cinnamon, and cool the . mixture on medium heat, stirring frequently until almost done – ½ hour. Reduce the heat and simmer until the mixture thickens into a soup. Serve hot. Serves 4.

Sautéed Potatoes with Sumac

baṭāṭā bi-summā'

1 pound potatoes
1 cup olive oil
2 cloves garlic, crushed
2 onions, sliced
2 tablespoons sumac
salt to taste

Wash, peel and dice the potatoes. Sprinkle with salt and set aside in a colander. Dissolve the sumac in ½ cup of boiling water and strain. Add garlic to the sumac juice and set aside. Heat the oil and sauté the potatoes. Pour on the sumac and garlic mixture and let stand to soak up the juices. Meanwhile, sauté the onions until golden and add them to the potatoes. Serve warm. Serves 4.

Potato with Tahini Sauce

baṭāṭā bi-ṭaḥīnī

5 medium potatoes
1 cup tahini
4 cups lemon juice
2 cloves garlic, crushed
2 tablespoons water
2 tablespoons chopped parsley
salt

Wash the potatoes well and boil them. When done, remove them to the side to cool. Peel and dice them.

Meanwhile, in a mixing bowl, prepare the *tahini* sauce by blending the *tahini* with garlic, lemon juice and water, beating continuously with a wooden spoon, until the sauce becomes creamy and smooth. Pour the *tahini* over the potatoes in a deep bowl and garnish with chopped parsley. Serves 4.

Hot Spicy Potatoes

baṭāṭa mḥarḥara

2 pound potatoes
2 bunches fresh coriander, finely chopped
10 cloves garlic, crushed
½ cup oil
½ teaspoon salt
½ teaspoon red hot chili pepper
1 tablespoon pomegranate molasses

Wash, peel and dice the potatoes. Pat them dry with a paper towel. Fry until golden. Add the coriander, garlic, red chili pepper and pomegranate molasses to the frying pan and toss for 3 minutes. Season and serve. Serves 6.

Potatoes with Chickpeas and Tomatoes in Olive Oil

msa'a'et baṭāṭā

2 pound potatoes, peeled and sliced
4 tomatoes, skinned, seeded and chopped
2 large onions, sliced
½ cup olive oil
½ cup dried chickpeas, soaked overnight and skinned
3 cloves garlic
2 tablespoons tomato paste, mixed with water
salt and freshly ground pepper

Cook the chickpeas in unsalted water until tender. Meanwhile, sauté the onions in oil until golden. Add the chickpeas and garlic and sauté for 5 minutes. Add the potatoes and continue tossing until well browned. Add the tomatoes and tomato paste.

Season with salt and pepper, cover and simmer gently about 25 minutes. Be careful not to scorch. Add a little water if necessary. Serve warm or cold. Serves 6.

Warm Chickpeas in Lemon and Oil Dressing

fattet ḥummuṣ

2 cups dried chickpeas, soaked overnight
½ cup olive oil
½ cup lemon juice
2 cloves garlic
1 loaf stale flat bread, broken into croutons
salt and pepper

Wash and boil the chickpeas until tender. Remove from the pot and reserve the liquid. Press the chickpeas with a rolling pin to skin and crack them. Return them to the pot on low heat to keep warm.

Meanwhile, mix the lemon, garlic, oil and seasoning well.

Just before serving, line a deep bowl with the bread croutons, sprinkle 3 teaspoons of chickpeas liquid, top with chickpeas, and pour on the lemon and garlic dressing. Serve immediately. Serves 4.

Chickpeas in Laban

fattet ḥummuṣ bi-laban

1 cup dried chickpeas, soaked overnight
2 cups laban
2 cloves garlic
1 tablespoon dried mint leaves
1 loaf Arabic bread
3 tablespoons pine nuts
3 tablespoons butter
salt and pepper to taste

Drain the chickpeas and boil them until tender. Break the Arabic bread into two parts and brown in a slow oven about 10 minutes. Break the pieces into croutons and set aside. Crush the garlic and add it to the *laban* in a mixing bowl. Season with salt and pepper. Add the mint leaves and beat well. Drain the chickpeas and reserve the liquid. In a deep bowl, place one layer of bread croutons and moisten them with warm chickpeas stock. Top with chickpeas and cover with the *laban* mixture. Repeat the layers until all the ingredients have been used and the last layer is a *laban* mixture. Brown the nuts in 3 tablespoons butter and spread them over the *laban* layer. Serve immediately. Serves 4.

Chickpeas Dip

ḥummuṣ bi-ṭaḥīni

1 cup dried chickpeas, soaked overnight
2 cloves garlic, crushed
3 tablespoons tahini
½ cup lemon juice
1½ teaspoons salt
2 tablespoons chopped parsley
1 tablespoon olive oil

Boil the chickpeas in water until done. Drain and rub them with the palms to remove the skin. Mash while warm in a food processor, leaving out a few whole ones for garnishing. Add *tahini*, lemon juice, salt, and 2 tablespoons of cold water. Blend the mixture until it is of creamy consistency. Correct the seasoning and pour the thick dip into a deep bowl. Garnish with whole chickpeas and chopped parsley. Sprinkle with olive oil and serve with flat Arabic bread. Serves 4.

Variation
Chickpeas Dip with Pine Nuts

ḥummuṣ bi-ṣnūbar

2 cups hummus (see above)
½ cup pine nuts
2 tablespoons butter, or 1 tablespoon samneh

Prepare the *hummus* and swivel it into a deep bowl. Sauté the pine nuts in butter and pour into the center of the *hummus* bowl. Serves 4.

Chickpeas with Olive Oil Dressing

ḥummuṣ msabbaḥ

1 cup dried chickpeas, soaked overnight
½ cup olive oil
2-3 cloves garlic, crushed
¾ cup lemon juice
2 tablespoons chopped parsley
salt to taste

Boil the chickpeas in deep water until tender. Drain and skin them by pressing with a wooden rolling pin or with the palms of the hands. Remove to a deep serving bowl.

Meanwhile, mix the garlic with the salt, lemon juice and olive oil. Pour the dressing over the warm chickpeas and garnish with chopped parsley. Serve warm with flat Arabic bread. Serves 4.

Bean Patties

falāfel

1 cup dried broad beans or fava beans,
* soaked overnight*
1 cup chickpeas, soaked overnight
2 large cloves garlic, crushed
½ cup chopped parsley
½ cup chopped spring onions
1 teaspoon ground cumin
½ cup chopped coriander
¼ teaspoon freshly ground black pepper
salt
oil for deep-frying
½ teaspoon baking soda

Boil the beans and peas separately until tender. Drain and grind them in a food processor. Mix in the onions, parsley, garlic, coriander, cumin, soda, and season with salt and pepper. Blend to a smooth paste and set aside for 30 minutes.

Shape the mixture into patties one-inch in diameter and deep-fry in hot oil until well browned. Remove to absorbent paper to drain.

Serve with flat pita bread and *taratūr* or parsley dip (see recipes page 73). Serves 4-6.

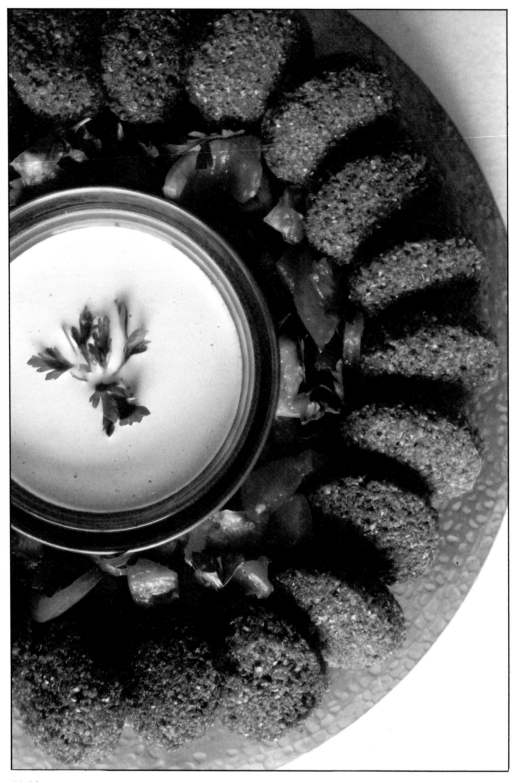

falāfel

114

Thick Bean Soup

makhlūṭa

1 cup chickpeas, soaked overnight
1 cup dried small white beans or navy beans,
 soaked overnight
½ cup burghul
½ cup uncooked rice
½ cup hulled whole wheat
1 cup olive oil
2 onions, chopped
1 teaspoon cumin
2 teaspoons salt
½ teaspoon allspice
½ teaspoon cinnamon

Boil the chickpeas, beans and wheat until
well done.

Add the rice and *burghul.* Brown the
onions in oil, season and add to the
mixture.

Bring to the boil until the stock is reduced
and the soup is thickened. Correct the
seasoning and serve hot. Serves 6-8.

Rice

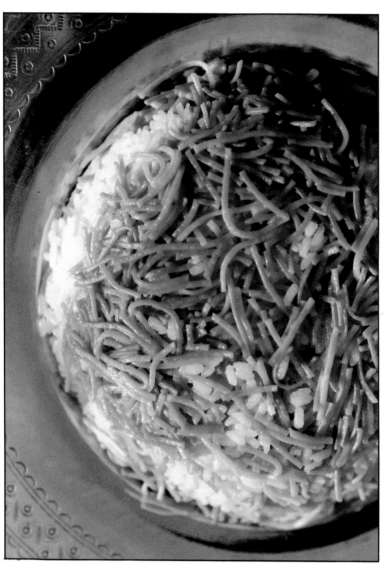

Historically, rice is a relative newcomer to Lebanon; wheat was the most important grain crop grown in the country. Today the Lebanese consider rice a staple food but continue to import it from Egypt, Asia and America.

For many, a meal without rice is inconceivable. The preferred method of cooking it is to boil it in water with butter or oil. It is often served with cooked vegetables on the side, as a pilaf mixed with nuts or legumes, or in *laban* as a thick soup.

To cook rice the Lebanese way, always wash off the extra starch and soak the rice, to prevent splitting and sticking. To heat leftover rice, sprinkle a tablespoon of water, and place it on very low heat, stirring occasionally.

riz bi-sh'ayriyyeh

Rice

riz mfalfal

2 cups uncooked rice
2 tablespoons butter
3 cups water
2 teaspoons salt

Wash and soak the rice in hot water for 10 minutes. Melt the butter in a cooking pot and add water and salt. Cover and bring to the boil. Drain the rice and add it to the water. Cover and cook on high heat for 5 minutes, or until the rice begins to absorb the water. Reduce the heat and simmer without further stirring, until the water is absorbed completely and perforations appear – about 15-20 minutes. Allow the rice to settle on the side of the stove for 10 minutes before serving. Stir gently when ready to serve. Serves 4.

Rice Pilaf with Vermicelli

riz bi-sh'ayriyyeh

1 cup uncooked rice
⅔ cup vermicelli broken into small pieces
2 cups water
3 tablespoons butter
1 teaspoon salt

Wash and soak the rice in hot water for 10 minutes. Melt the butter in the cooking pot on high heat and toss the vermicelli until golden brown. Add the rice and stir until well mixed with the vermicelli. Pour in hot water and add salt. Cook uncovered until the water is reduced to just above the level of the rice. Reduce the heat, cover, and cook for 15-20 minutes or until perforations appear. Remove to the side for 5 minutes before serving. Serves 4.

Fried Rice

riz m'alla

2 cups long-grained uncooked rice
2 medium onions, thinly sliced
3 cups vegetable stock
2½ tablespoons butter
1 teaspoon salt

Soak the rice in boiling water for 10 minutes. Drain well and set aside. In a cooking pot melt butter and add the rice and onions. Stirring continuously to prevent sticking, sauté the rice and onions until golden – about 10 minutes. Add the stock, cover and bring to the boil on high heat. Cook until the liquid is reduced to just above the rice level. Reduce the heat and simmer until perforations appear. Allow the rice to settle for 5 minutes before stirring it. Serve topped with **Hot Spicy Mushrooms** (see recipe page 101). Serves 4-6.

Hot Spicy Pilaf

riz bi-ḥarr

3 loaves Arabic bread, broken into croutons
½ cup uncooked rice
1 tablespoon butter or samneh
3 cloves garlic
½ teaspoon dried mint leaves
1 teaspoon salt
1 hot green chili pepper, chopped
1 medium onion, chopped
1 tablespoon pomegranate molasses

Crush the garlic with the mint leaves, salt, and chili pepper in a mortar with a pestle. Add the pomegranate molasses and set aside. Wash and drain the rice. Brown the onions and add them to the rice and cook until the rice is almost done, see recipe for **Rice** page 117. Mix the garlic mixture with the bread croutons. Season with salt and pepper and add to the rice 5 minutes before it is done. Mix well and keep on very low heat until the rice is fluffy. Serves 4-6.

Cabbage Pilaf

ma'lūbet malfūf

4 pounds cabbage
2 cups long-grained rice
½ cup butter or samneh
2 medium onions, chopped
3 heads garlic, whole unpeeled
½ teaspoon cumin
½ teaspoon cinnamon
salt

Heat the oil and brown the onions and garlic. Wash and chop the cabbage leaves very fine and set aside. Chop the remaining stalks of the cabbage leaves and add them to the onions and garlic. Add butter and water and bring to the boil. Lower the heat and cook for 10 minutes. Add to the pot half the cabbage leaves and all the rice. Cover with water and cook until the stock is completely reduced and rice is done.

Prepare a salad with the remaining cabbage leaves, using a lemon and garlic dressing, and serve it on the side. Serves 6.

Swiss Chard Pilaf

ma'lūbet sil'

1 pound Swiss chard
1 cup uncooked rice, washed and soaked
 for 10 minutes
½ cup olive oil
½ cup chopped spring onions
1 lemon, squeezed
½ cup chopped parsley
salt and allspice or bhar

Wash the Swiss chard well. Remove the stalks and chop. Chop the leaves and set aside to drain.

Heat the oil and sauté the spring onions until soft. Season with salt and allspice or *bhar*. Add the rice and toss for a few minutes. Add the chard stalks, leaves and parsley.

Add 1½ cups of boiling water and bring to the boil uncovered. Cover, reduce the heat and simmer until the rice is cooked – about 15-20 minutes. Allow the rice to stand for a few minutes before serving. Serves 4-6.

Eggplant Pilaf

ma'lūbet bātinjān

2 long eggplants with their skins, cubed
2 medium onions, sliced
⅓ cup olive oil
3 ripe tomatoes, peeled and chopped
1 teaspoon salt
½ teaspoon black pepper
2 tablespoons chopped parsley
2 tablespoons chopped mint leaves
2 cups uncooked long-grain rice
2½ cups water
laban

Sprinkle the eggplant cubes with salt in a colander and set aside for one hour to drain the bitterness. Rinse and dry well with a paper towel. Heat half the oil in a heavy-based pan and sauté the eggplant cubes until lightly browned. Remove to absorbent paper to drain excess oil.

Add the remaining oil and sauté the onions until transparent. Add the tomatoes, parsley, mint leaves and seasoning. Mix with the eggplant in a deep pot. Rinse the rice and add it to the mixture. Cover with water and bring to the boil without stirring. Reduce the heat, cover and simmer gently for 25 minutes. Remove to the side for a few minutes. Unmold on a dish and serve with *laban* on the side. Serves 6.

Cauliflower Pilaf

ma'lūbet arnabīṭ

2 cups uncooked rice
2 pounds cauliflower
½ cup olive oil
1 bunch fresh coriander, chopped
4 cloves garlic, crushed
salt and pepper
½ cup lemon juice

Wash the rice well and soak it for 10 minutes in warm water. Meanwhile, break the cauliflower into florets, wash and dry them.

Heat the oil in a pot and sauté the cauliflower. Add the garlic and coriander, season with salt, and add ½ cup water. Cover and cook over low heat for 5 minutes or until half done. Add the rice and water to cover, season with salt to taste, and continue cooking for 15 minutes until the stock is reduced and perforations appear.

Remove to the side for 5 minutes before unmolding on a serving dish. Serves 4-6.

Chickpeas Pilaf

riz bi-dfīn

1 cup uncooked rice, soaked 10 minutes
½ cup chickpeas, soaked overnight
½ cup olive oil
1 medium onion, chopped
1 teaspoon salt
1 teaspoon cinnamon
¼ teaspoon allspice

Bring the chickpeas to the boil in salted water, cook until tender. Drain and set aside.

Meanwhile, in a deep pot, sauté the onions in oil and seasonings. Add the chickpeas and rice and 1½ cups of water, and cook uncovered on high heat until the stock is reduced to just above the level of the rice. Reduce the heat, cover and simmer for 15 minutes or until perforations appear. Set aside for 10 minutes before serving. Serve with *laban* on the side. Serves 4-6.

Fresh Broad Bean Pilaf

riz bi-fūl akḍar

1 cup uncooked rice, washed and soaked
 for 10 minutes
2 pounds fresh broad beans or fava beans,
 podded
1 bunch fresh coriander, chopped
1 medium onion, chopped
4 cloves garlic, crushed
½ cup oil
1 teaspoon salt
½ teaspoon cinnamon
¼ teaspoon allspice or bhar

Heat the oil and brown the onions until
transparent. Add the coriander, garlic,
beans and seasonings and toss for 5
minutes. Cover with water and cook until
the beans are tender. Add the rice and
cover with 1½ cups water. Bring to the boil
uncovered.

 Cover and simmer on low heat until the
water is reduced and perforations appear.
Allow to stand for 10 minutes and serve
with *laban*. Serves 4-6.

Zucchini Pilaf

ma'lūbet kūsā

2 pounds zucchini, diced
1½ cups uncooked rice, soaked
 for ½ hour
1 large onion, chopped
3 ripe tomatoes, skinned, seeded
 and chopped
½ cup olive oil
salt and pepper
½ teaspoon cinnamon

Heat the oil in a deep pot and sauté the
onions. Season with salt, pepper and
cinnamon. Add the zucchini and toss for 5
minutes to brown lightly. Add the tomatoes
and simmer for 5 minutes longer. Add the
drained rice and 3 cups of water, and bring
to the boil uncovered for 10 minutes.
Reduce the heat, cover and simmer for 15
minutes or until the rice is done.

 Remove to the side for 10 minutes before
serving. Serves 4-6.

Rice and Laban Soup

labniyyeh

½ cup uncooked rice
3 cups laban
2 tablespoons butter
6 cloves garlic, crushed
1 tablespoon cornstarch, diluted
 in a little water
1 teaspoon salt
1 teaspoon dried mint leaves, crushed

Mix the cornstarch with the *laban* and add a
little water. Place on low heat, stirring
continuously, until the mixture thickens to a
creamy consistency. Add the rice and salt
and stir occasionally until the rice is done.
Add more water if needed. Mix the garlic
with dried mint leaves and add to the rice.
Bring to the boil and remove from the heat.
Serve the *labniyyeh* hot. Serves 4.

Burghul

burghul bi-banadūra

Archeologists have established that wheat must have been grown in the Middle East some 5,000 years ago. Wheat is indigenous to Lebanon and grows today on irrigated land. It is used in different forms – whole, ground as flour, and cracked as *burghul.* Until recently, *burghul* was much more common than rice in the daily diet of the Lebanese. It is wheat grain, boiled, dried and ground into coarse, medium and fine. *Burghul* is cooked much like rice, as a pilaf, added to dried legumes or fresh vegetables, and when soaked raw and uncooked, it forms the base for the national salad *tabbūleh.*

Meals made with *burghul* are wholesome and delicious. Use the coarse quality for pilafs and soups, the medium for salads and the fine for *kibbeh.*

Spinach Kibbeh

kibbet sbēnekh

3 pounds spinach
1 cup finely chopped spring onions
1 large onion, chopped
2 bunches fresh coriander, finely chopped
½ cup fine burghul, soaked for 2 hours
1½ cups chickpeas, soaked overnight
5 cups flour
1¼ cups oil
2 teaspoons salt
1 teaspoon allspice or bhar
2 tablespoons butter

Wash the spinach, remove the stalks and chop.

Bring the chickpeas to the boil in salted water until tender.

Meanwhile, in a mixing bowl, place the flour, spring onions, coriander and seasoning. Squeeze the *burghul* well to press out the absorbed water and add it to the flour mixture. Add enough water to form a soft dough, knead well, and spread one half of the mixture in the bottom of a greased baking pan. Leave the remaining dough for the top layer.

Filling:

Heat the oil and sauté the onions until golden. Add the chickpeas and sauté 5 minutes longer. Add the spinach and cook for 15 minutes until the liquid is reduced and the spinach is done.

Spread the filling over the layer of dough in the baking pan. Top with another layer of the remaining dough.

Cut through the top layer in diamond shapes with a sharp knife making sure not to reach the bottom when cutting. Top with melted butter and bake at 400° for 30 minutes. Serves 6.

Fake Kibbeh in Laban

kibbet ḥīleh bi-laban

1 cup flour
1 cup fine burghul
4 cups laban
5 cloves garlic, crushed
1 bunch coriander, chopped
salt and bhar to taste

Mix the flour with the *burghul* in a mixing bowl. Add salt and *bhar* to taste, and with a little water, knead into a dough. Roll the dough into marble-sized balls and set aside.

Prepare the *laban* according to the recipe for **Cooked Laban** on page 43. Sauté the garlic and coriander in oil and blend into the *laban*. Drop the *kibbeh* balls in the *laban* and cook until done. Serve hot as a soup. Serves 4-6.

Fine Burghul Loaf

ṣwayq

2 cups srīra (see glossary)
1 bunch fresh parsley, chopped
1 bunch fresh mint, chopped
½ teaspoon marjoram
½ cup olive oil
1 teaspoon salt

Mix the *srīra* with the parsley and mint, adding enough water to make a dough. Knead well into a soft dough. Add seasoning and marjoram and continue kneading. Grease a baking dish and spread the mixture evenly. Cut through in diamond shapes with a sharp knife. Top with olive oil and bake in a 450° oven for 30 minutes. Serves 4-6.

Fake Kibbeh Soup

zingol bi-ḥāmuḍ

2 cups burghul, soaked for 1 hour
1 cup flour
1 teaspoon salt
1 cup chickpeas, soaked overnight
 (lentils may be substituted)
3 tablespoons sumac
10 cloves garlic, crushed
2 large onions, finely chopped
1 cup oil
½ cup lemon juice

Mix the *burghul*, flour and salt with enough water to make a dough. Form into small marble-sized balls. Sauté the onions in oil, add the chickpeas, and cook in 3 cups of water until done. Add water if necessary. Drop the *burghul* balls into the pot. Sauté the garlic, add sumac, and add to the pot. Cook for 10 minutes and serve the soup hot. Serves 4-6.

Potato Kibbeh

kibbet baṭāṭa

4 cups mashed potatoes
1 cup burghul
½ cup flour
1 teaspoon salt
½ teaspoon allspice or bhar
2 medium onions
1 bunch fresh coriander, chopped

Wash the *burghul*. Place the mashed potatoes in a mixing bowl. Squeeze the *burghul* well to press out the absorbed water and add it to the mashed potatoes. Chop the onions and coriander very fine, using a food processor, and fold in. Add the flour, salt and allspice. Knead well to form a soft dough. Spread ½ of the mixture in the bottom of a greased baking pan. Top with the walnut filling and cover with the second half of the potato mixture.

Walnut filling:
½ cup walnuts, chopped
3 onions, chopped
2 tablespoons pomegranate molasses
salt and allspice
2 tablespoons oil

Heat the oil and sauté the above ingredients until softened. Set aside to cool. Use the mixture as filling for the kibbeh. Serves 4-6.

Potato Kibbeh Patties

Form the potato mixture described in the master recipe above into flat rounds the size of a small hamburger. Sauté in deep hot fat until browned on both sides. Serve with a green salad.

Potato Kibbeh Balls

kibbet baṭāṭa d'ābīl

Again using the mixture in the master recipe, form small oval balls. Make a hole in them working your finger in the hole to form a cup. Fill it with the walnut mixture. Seal and sauté or bake the balls. This variation is often served with drinks.

Potato Herb Kibbeh

kibbet baṭāṭa ('Amshīt)

2 pounds potatoes, boiled and mashed
1 cup burghul
1½ cups walnuts and almonds, ground
1 onion, finely chopped
1 tablespoon chopped fresh rose-geranium
¼ teaspoon marjoram
1 tablespoon chopped fresh mint leaves
½ cup olive oil
salt and pepper

Mix the potatoes with the *burghul,* onions, parsley, nuts, marjoram and rose-geranium. Knead well into a dough. Season with salt and pepper and shape into balls the size of an egg. Sprinkle with olive oil and serve. Serves 4-6.

Pumpkin Kibbeh

kibbet la'tīn

2 pounds pumpkin
2 cups flour
5 onions, sliced
½ cup chopped shelled walnuts
½ cup pine nuts
½ cup chickpeas, soaked overnight
2 cups burghul
½ loaf Arabic bread, sliced into croutons
2 tablespoons lemon juice
salt and pepper

Cover the chickpeas in water and cook until done.

Peel the pumpkin and slice into one-inch pieces. Boil until tender. Use the water to pour over the *burghul* and set aside to soak for one hour.

Filling:

Brown the onions in oil and add the croutons of bread, walnuts and pine nuts. Season with salt and toss over medium heat. Add the chickpeas, lemon juice and set aside.

Drain the *burghul* and squeeze it dry. Add the flour and pumpkin and knead to make a dough.

Roll the dough into small balls all the while dipping your hands in cold water. Make a hole in the center working your finger around the hole to form a hollow shape. Fill the hole with the nut mixture and close. Moisten the *kibbeh* ball with cold water to smooth and seal it.

Deep-fry the *kibbeh* balls until evenly browned. Lift out to absorbent paper to drain.

Serve warm or cold. Serves 8.

Burghul and Spinach Pilaf

burghul bi-sbēnekh

4 pounds spinach, cleaned and chopped
2 onions, chopped
¾ cup coarse burghul
2 tablespoons oil
salt and allspice to taste
½ cup chickpeas, soaked overnight

Boil the chickpeas until tender and set aside.

Heat the oil and sauté the onions until transparent. Add the spinach and seasoning and toss a while longer. Cover and simmer until the spinach is almost done. Add the *burghul* and chickpeas. Cover without stirring and simmer on low heat until the *burghul* is done. Before serving, mix the pilaf and serve with *laban* on the side. Serves 4-6.

Burghul and Lentil Pilaf

mdardra bi-burghul

1 cup lentils
1 cup burghul
1 large onion, sliced
½ cup olive oil
salt and allspice or bhar

Bring the lentils to the boil in a deep pot. Cook until half tender.

Meanwhile, sauté the onions in oil and add them to the pot. Season with salt and allspice. Add the *burghul* and bring back to the boil uncovered. Reduce the heat, cover and simmer for 15 minutes or until the stock is completely reduced and perforations appear. Serve with *laban* or salad. Serves 4-6.

Burghul and Mallow Pilaf

burghul bi-khubbayzeh

3 pounds mallow
1 onion, finely chopped
2 cups coarse burghul
½ cup olive oil
salt and allspice or bhar
3 cups water

Remove the stalks of the mallow leaving only the very tender ones. Wash very well under cold running water. Drain and chop the leaves and tender stalks, and set aside.

Meanwhile, wash the *burghul* and soak it for 5 minutes.

Heat the oil and sauté the onions until transparent. Season with salt and allspice or *bhar*. Bring the water to the boil in a cooking pot. Add the onion and *burghul* and bring to the boil. Lower the heat and simmer for 10 minutes or until the stock is half absorbed. Add the mallow and simmer for 5 minutes longer or until all the liquid is reduced and perforations appear. Remove to the side for 10 minutes before serving. Mix well and serve. Serves 4-6.

Burghul and Tomato Pilaf

burghul bi-banadūra

2 cups burghul
1 large onion, chopped
3 medium tomatoes, skinned, seeded and
 chopped
½ cup olive oil
salt and allspice or bhar
3 cups cold water
¼ teaspoon chili pepper (optional)

Wash the *burghul* and soak it for 5 minutes.
Heat the oil and sauté the onions until
transparent. Add water and bring to the
boil. Add the *burghul* and season with salt
and allspice. Cover and simmer for 10
minutes or until the liquid is half absorbed.
Add the tomatoes and simmer for 5 minutes
longer until all the liquid is absorbed and
perforations appear. Remove from the heat
and bake in a preheated oven for 10
minutes uncovered. Serves 6.

Burghul with Fresh Broad Bean Pilaf

burghul bi-fūl akhdar

2 pounds fresh broad beans or fava beans,
 shelled
1 cup burghul
2 tablespoons samneh or butter
1 bunch coriander, chopped
3 cloves garlic, crushed

Heat the *samneh* and sauté the garlic,
coriander and beans. Cover with water and
add the *burghul*. Bring the pot to the boil
uncovered. Reduce the heat, cover and
simmer until all the stock is absorbed and
perforations appear. Remove to the side of
the stove for 10 minutes before serving.
Serve with **Laban and Cucumber Salad.**
Serves 4-6.

Kishk Soup

shorbit kishk

1 cup kishk (see glossary)
3 tablespoons butter, or 1 tablespoon samneh
10 cloves garlic, whole
1 medium onion, chopped
1 bunch coriander, chopped
2 cups shredded cabbage
2 tablespoons dry mint leaves
salt and pepper to taste
4 cups water

Brown the *kishk*, garlic, onion and coriander
in butter. Add water gradually, stirring
continuously. Season with salt and bring to
the boil. Reduce the heat and simmer,
stirring occasionally to prevent sticking.
When the *kishk* is half done, add the
shredded cabbage and cook for 10 minutes,
adding water if necessary, until the soup is
creamy and thick. Sprinkle with crushed
mint leaves and serve in deep bowls.
Serves 6.

Raw Kishk

kishkeh khaḍra

1 cup kishk (see glossary)
1½ cups laban
1 small onion, finely chopped
½ cup chopped parsley
¼ cup chopped fresh mint leaves
½ teaspoon chili pepper
½ teaspoon crushed dried mint leaves
¼ cup chopped walnuts
10 green olives, pitted
olive oil

Blend the *kishk* with the *laban*. Add the parsley, mint, onion, and chili pepper, and, mix well. Spoon into a small serving bowl and garnish with walnuts and olives. Sprinkle on olive oil and serve with flat Arabic bread. Serves 4.

Kishk Vegetable Soup

kishk bi-tidmij

1 pound cauliflower, broken into florets
5 onions sliced
1 whole head of garlic, crushed
5 bunches coriander, chopped
flat bread dough, enough for three loaves
1 cup kishk (see glossary)
1 cup olive oil
1 tablespoon pomegranate molasses
red chili pepper, optional
salt and pepper to taste
stale flat Arabic bread, broken into croutons
olive oil

Sauté the onions, coriander and garlic in oil. Reserve half the quantity. Add water, *kishk* and pomegranate molasses to the remaining half. Bring to a simmer and cook until the liquid is reduced.

Meanwhile, roll the dough into long macaroni-like threads. Slice into one-inch pieces and drop into the *kishk*. Cook for 10 minutes.

Pour the *kishk* mixture in a deep bowl, add the croutons, and top with reserved cauliflower, onions, garlic and coriander. Serve hot. Serves 4-6.

Hot Burghul Salad

ṣafṣūf

1 cup burghul, soaked for 10 minutes
4 cups chopped parsley
½ cup chopped spring onions
½ cup chopped fresh mint leaves
2 tablespoons samneh or butter
cabbage leaves or fresh vine leaves,
 lightly boiled

Heat the *samneh* and toss the *burghul*, parsley, onions and mint leaves. Add a little water and simmer until the *burghul* is done. Serve hot with poached cabbage or vine leaves. Serves 4-6.

Pastry

Lebanon boasts a variety of pastries (moon-shaped, finger-shaped, triangles, and rounds) made of pie pastry, flaky pastry or bread dough. Fillings vary from cheeses to leafy vegetables such as spinach, Swiss chard, purslane and sorrel, to spreads of herbs and spices.

All of these savory pastries require a certain amount of skill and involve the preparation of a dough. For best results use strong plain flour and fresh yeast when available. Refrigerate fresh yeast in airtight bags and it will keep for 3-4 weeks. Do not allow dough containing yeast to rest for too long (not longer than 1½ hours at room temperature or 45-60 minutes in a warm place) as the effect of the yeast will be lost in the cooking. Always cover the resting dough with a damp cloth. The dough is sufficiently risen when it has doubled in size and when it springs back into shape if pressed. A good kneading strengthens a dough and renders it pliable.

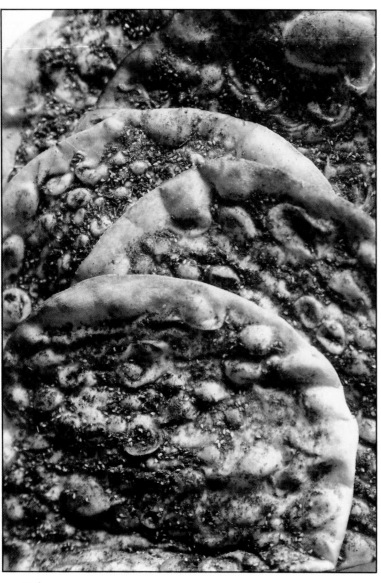

mnā'īsh

128

Spinach Turnovers

faṭāyer bi-sbēnekh

3 cups flour
½ cup olive oil
2 teaspoons dry yeast granules blended in
 3 teaspoons warm water
½ teaspoon salt
1 cup lukewarm water

Combine the flour and the dissolved yeast and rub well. Add the oil and knead, adding enough water to form a pliable soft dough. Cover and set aside for 2 hours to allow the dough to rise. Roll out the dough on a lightly floured board. Cut it in rounds with a biscuit cutter.

Filling:
2 pounds fresh spinach, chopped
½ cup chopped onions
1 cup lemon juice
1 tablespoon sumac
½ cup olive oil
1¼ teaspoon salt
1 teaspoon allspice or bhar

Wash and drain the spinach and rub it well with salt. Combine it with the other ingredients. Add more lemon juice if desired. Place one tablespoon of this filling on each round of dough. Fold over in a triangular shape. Pinch the three edges firmly to prevent the turnover from opening while baking. Place the turnovers on a greased baking sheet. Bake at 350° until lightly browned. You should have 25-30 turnovers.

Purslane Turnovers

faṭāyer bi-ba'leh

4 bunches purslane,
 stemmed, washed, and patted dry
2 small onions, minced
1 teaspoon salt
pepper to taste
1 cup lemon juice
½ cup olive oil

Prepare the dough according to the steps described in the recipe for **Spinach Turnovers** above.
 Mix the above ingredients well and use them as a filling. Proceed to bake as indicated in the recipe.

Variation

Sorrel Turnovers

faṭāyer bi-ḥummayḍa

Using the same ingredients as in the above purslane filling, replace the purslane with the sorrel and proceed to fill the pastry to form the sorrel turnovers.
 Bake according to the directions in the recipe for **Spinach Turnovers**.

Half-Moon Pies

sambūsek

2 cups flour
¾ cup oil
½ teaspoon dry yeast granules
¼ cup water
½ teaspoon salt

To prepare the pastry, blend the yeast in one teaspoon warm water and a pinch of sugar. Set aside to rise. Rub the oil and salt into the flour. Work in the blended yeast and knead by gradually adding a ¼ cup water to make a stiff dough. Set aside for an hour.

Cheese Filling:

Mix:
¼ pound white cheese (Lebanese or Greek feta), chopped
2 hard-boiled eggs, chopped

Roll out the dough and cut it into rounds with a biscuit cutter. Place a teaspoon of filling in the center of each small round. For larger rounds use more filling. Fold over the round of dough into a crescent shape. Pinch the edges together and twist forward forming a fringe along the entire edge. Deep-fry the *sambūsek* in deep hot fat until browned. Drain on absorbent paper.

Labneh Filling:

1 cup chopped onions
3 tablespoons chopped parsley
2 tablespoons chopped green peppers (optional)
2 cups labneh (page 43)
salt and pepper

Mix the above ingredients and use as filling for the pastry.

Thyme-Flavored Bread

mnā'īsh bi-za'tar

1 cup dried thyme leaves
1½ tablespoons sumac
2 tablespoons toasted sesame seeds
1 teaspoon salt
1 teaspoon chili pepper
1 cup olive oil
1 onion, very finely chopped

Mix the above ingredients in a mixing bowl to form a thick paste and set aside.

Prepare the dough:

5 cups plain flour
1 sachet active dry yeast,
 dissolved in ¼ cup water
1 teaspoon salt
¼ cup oil
water

Pour the yeast liquid in all but one cup flour and blend well. Add oil gradually and beat well.

Knead with the remaining flour until the dough is smooth. Shape into a ball and set aside covered for about 2 hours. It should rise to double its size.

On a lightly floured board, spread the risen dough, then divide it into 7-8 equal pieces rolled into balls.

With a rolling pin, roll each ball to a 10-inch round and place it on a floured cloth. Cover and let stand for 10 minutes. Meanwhile, heat the oven to 475°.

Remove rounds of dough to a lightly floured baking sheet and pinch the surface of the dough to prevent puffing during baking. Spread the thyme mixture on each loaf and bake for 5 minutes. Serves 4-6.

Kishk Bread

mnā'īsh bi-kishk (Deir Koubel)

bread dough for **mna'īsh bi-za'tar** *above*
1 cup kishk
1 cup srīra *(see glossary)*
1 tablespoon paprika
½ teaspoon hot red chili pepper
1 tablespoon tomato paste, diluted in water
1 teaspoon pomegranate molasses
1 onion, finely chopped
salt to taste
¾ cup olive oil

Soak the pepper and paprika in half the oil and tomato sauce. Add the *kishk*, *srīra*, minced onion, pomegranate molasses and oil. Blend well to form a paste.
This part may be prepared the day before:
 Prepare your flat bread dough according to the recipe for **mnā'īsh bi-za'tar.**
 Spread the mixture on the loaves of bread and bake in a hot oven for 5 minutes. Serves 4-6.

Variation

Kishk Loaves with Cheese

mnā'īsh bi-kishk (Baalbeck)

dough, see master recipe
1 cup kishk *(see glossary)*
1½ tablespoons sumac
1 teaspoon red chili pepper
1 onion, finely chopped
1 cup chopped white cheese, feta or hallūm
olive oil

Mix the above ingredients together and spread the mixture on the individual loaves as described in the master recipe. Bake for 5 minutes in a hot oven. Serves 4-6.

Hot Spicy Bread

mnā'īsh bi-ḥarr (Deir Koubel)

1 cup kishk *(see glossary)*
1 tablespoon pounded red chili pepper
2 tablespoons sesame seeds
½ cup olive oil
dough for **mnā'īsh bi-za'tar** *(page 130)*

Dissolve the *kishk* in a little cold water to form a thick paste. Add the chili pepper, sesame seeds and olive oil.
 Prepare the dough and shape into small round flat loaves – about 5 inches. Spread the *kishk* mixture over the loaves and bake in a hot oven for 10 minutes or until done. Serve hot. Serves 6.

Puff Pastry Filled with Walnuts

boerek bi-jawz

10 sheets fillo pastry
4 onions, finely chopped
1 cup chopped walnuts
½ cup coarse breadcrumbs
1 tablespoon lemon juice
1 teaspoon pomegranate molasses
½ cup olive oil
salt and pepper

Heat the oil and brown the onions. Add the walnuts, breadcrumbs and seasoning. Finally add lemon juice and pomegranate molasses, and set aside. Use as a filling.

Roll the pastry out and cut into 3-inch squares. Place one teaspoon of filling along the edge of each square and fold in the sides. Roll into finger shapes pressing the edges together with wet fingers. Place on a greased baking tray and bake for 20 minutes until golden.

Variation

Puff Pastry Filled with Cheese

boerek bi-jibneh

White cheese filling:

1½ cup crumbled feta cheese or sweetened
 Lebanese akkāwi cheese
1 egg
½ cup chopped parsley
ground pepper

Beat the egg lightly and add the crumbled cheese and pepper. Use as a filling for fillo pastry as in the master recipe above.

Puff Pastry Filled with Spinach

boerek bi-sbēnekh

Spinach filling:
1 pound fresh spinach
1 onion, finely chopped
¼ cup olive oil
1 egg
½ cup white Lebanese akkāwi cheese,
 (sweetened) or feta cheese
¼ cup chopped parsley
salt and pepper to taste

Clean, wash and chop the spinach. Toss in a pan over medium heat until wilted. Squeeze out the moisture and add the onion, cheese, egg and parsley. Mix well and season. Use as filling for fillo pastry. Roll the pastry into large fat sausage-like shapes.

Macaroni with Laban Sauce

rishta bi-laban

1 pound macaroni or rishta (see glossary)
1 cup laban
2 cloves garlic, crushed
½ teaspoon dried mint leaves, crushed
1 tablespoon butter
½ cup pine nuts
1 tablespoon oil
½ teaspoon salt

Boil water in a deep cooking pan. Add oil to the boiling water and drop in the macaroni gradually without breaking it. Cook for 8-10 minutes until done but firm. Do not overcook. Remove to a colander and run under cold water to remove the starch. Set aside to drain.

Beat the *laban* well until smooth, add the garlic and crushed mint, and season.

In a frying pan, sauté the pine nuts in butter until golden.

Just before serving, blend the *laban*, fold in the macaroni and top with the pine nuts and butter. Serves 4-6.

Sweets and Desserts

Lebanon is famous for its sweetmeat shops, offering nut-filled pastries drenched in syrup and glazed, and a variety of crystallized fruits. Nobody knows the origin of this mixture of baked pastries stuffed with nuts, but it is thought that the very finely milled flour required for the paper-thin dough was first produced in the Middle East. Many of these sweets are served on social occasions and during special holidays.

To make these pastries at home, buy the fresh dough already prepared from the speciality shops since making the dough is a highly specialized art. The ready-made packaged dough available in supermarkets and shops will not give the same result.

Lebanese desserts also include grains (rice and hulled wheat) mixed with syrups and garnished with nuts, sweet potatoes and legumes and a variety of milk desserts and puddings.

atāyef bi-ahsta

Clotted Cream

ashṭa

There is more than one way of making clotted cream or *ashta*. All of them work. The following are three methods judged easy for home preparation.

Method I

1 cup powdered milk
4 cups water
1 tablespoon cornstarch

Bring the dissolved milk and cornstarch slowly to a simmer in a wide nonstick pan. When a skin forms on the surface, remove it with a large spoon to a side dish. Repeat this process every 10 minutes until only a thin layer of milk remains. Chill the collected cream thoroughly before using.

Method II

4 cups powdered milk
4 cups water
the juice of one lemon

Dissolve the powdered milk in water and bring to the boil in a nonstick pan. Add the lemon juice in drops to the milk. Simmer until a skin forms on the surface. Remove to the side and let stand for 2½ hours. A thick skin will form at the top. Remove to a side bowl and discard the remainder of the liquid. Chill overnight before using.

Method III

4 cups whole milk
1 cup heavy cream

Bring the milk and cream to the boil slowly in a wide nonstick pan. Reduce the heat to very low and simmer gently for 2 hours. Remove to the side and allow to stand for several hours until the cream is thick enough to be cut with a knife. Refrigerate overnight before using.

Syrup

aṭr

1 cup sugar
½ cup water
1 teaspoon lemon juice
1 teaspoon orange blossom water

Dissolve the sugar in the water and bring to the boil, stirring continuously. Reduce the heat and add the lemon juice. Simmer until the syrup thickens enough to coat the back of a spoon. Add the orange blossom water and use to sweeten desserts.

Almond Cream Pudding

mhallabiyyeh bi-lawz

3 cups milk
¼ cup ground rice
¾ cup ground almonds
1 tablespoon rose water
1½ tablespoons orange blossom water
¼ cup sugar
pinch of salt

Blend the rice in some of the milk and add it to the rest of the milk in a heavy saucepan. Add the sugar and salt and bring to the boil, stirring continuously. Reduce the heat and simmer, stirring frequently. Add the almonds and continue cooking. Stir in the flavoring of rose water and orange blossom water. Cook for a few minutes. Remove to the side to cool before pouring into individual dishes. Garnish with chopped almonds and pistachio nuts. Serves 4-6.

Rice Custard

mhallabiyyeh

4 cups milk
⅓ cup ground rice (or 2 tablespoons cornstarch)
½ cup sugar
1½ teaspoons orange blossom water
½ teaspoon rose water
½ teaspoon mistki, ground

Bring the milk to the boil. Mix the ground rice or cornstarch with water and add it to the milk. Stir over low heat until the milk thickens – about 20 minutes. Add the sugar and continue stirring. When the pudding coats the wooden spoon, add rose and orange blossom flavoring and stir for a few minutes longer. Serve in individual molds garnished with chopped walnuts, blanched chopped almonds and skinned pistachio nuts. Serves 4-6.

Rice Pudding

riz bi-ḥalīb

4 cups milk
½ cup uncooked rice, washed and soaked for ½ hour
1¼ cup cold water
½ cup sugar
1 tablespoon orange blossom water

Wash the rice well and add the milk to it in a saucepan. Add the water and bring to the boil on medium heat, stirring continuously. Boil the mixture for 40 minutes, stirring occasionally. Add the sugar and cook for an additional 10 minutes or until the pudding thickens and coats the spoon. Remove the saucepan from the heat and add the flavoring. Pour the pudding into a large serving bowl or into individual molds. Refrigerate. Serves 4-6.

Variation

Cornstarch and Rice Pudding

1 cup cornstarch
½ cup ground rice
1 cup sugar
1 teaspoon orange blossom water
1 cup chopped, skinned almonds, pistachio and pine nuts
8 cups water

Mix the cornstarch with a little water to a smooth paste.

In a deep pot, mix the rice with the rest of the water, and add the sugar and cornstarch. Bring to the boil slowly, stirring continuously. Lower the heat and simmer, stirring continuously until the mixture thickens and coats a spoon. Stir in the orange blossom water and cook for 3 minutes. Add nuts, stir, and pour into a large transparent bowl. Chill. Serves 4-6.

Baked Rice Pudding

riz bi-ḥalīb mjammar

½ cup uncooked rice
5 cups water
5 cups milk
2 tablespoons orange blossom water
3 tablespoons butter
1 cup breadcrumbs
syrup – see recipe on page 134

Boil the rice in the water on low heat until it is sticky and the water is reduced. Add milk and bring to the boil. Cook for 1½ hours until the rice is soft and creamy. Add orange blossom water and simmer for 3 minutes. Remove to the side.

Grease an ovenproof dish and sprinkle a layer of breadcrumbs. Pour the pudding into the dish. Top with breadcrumbs, dot with butter, and bake for 10 minutes. Serve warm with syrup. Serves 4-6.

Spicy Rice Pudding

mighlī

1 cup ground rice
9 cups water
1 tablespoon powdered caraway seeds
1 tablespoon powdered anise
1 teaspoon cinnamon
1 teaspoon of ground fennel
2 cups sugar
mixed nuts (walnuts, pine nuts, almonds), skinned

Bring the spices to the boil in the water and strain but reserve water. Add the rice gradually, and once again bring the mixture to the boil, stirring continuously. Add the sugar and stir until the pudding thickens enough to coat the wooden spoon. This requires one hour of cooking. Pour the pudding into individual dishes, cool and garnish with the mixed nuts. Serves 4-6.

Rice and Tahini Dessert

mfatta'a

1½ cups uncooked rice, soaked overnight in boiling water; the Egyptian variety is preferable
1½ cups tahini
3 cups sugar
2 tablespoons turmeric
½ cups pine nuts

In a nonstick pot, bring the rice to the boil in deep water. Simmer on low heat until it becomes pulpy and all the water has evaporated. Add more water when necessary. Add sugar, *tahini* and turmeric. Stir on very low heat with a wooden spoon for about 1½-2 hours. It should become thick and sticky. Add the pine nuts and pour into a flat serving dish. Smooth out with the back of the wooden spoon. Refrigerate, slice and serve a few hours later. Serves 8-10.

Cornstarch and Walnut Custard

khabīṣa

1 cup cornstarch (nasha)
2 cups sugar
3½ cups water
1 cup shelled walnuts, chopped
¼ teaspoon ground mistki

In a nonstick saucepan, mix the cornstarch with cold water, add sugar and bring to the boil stirring continuously, until the mixture becomes glutinous. Add the *mistki* and walnuts, blend well and arrange in small mounds on a tray and serve cold. Serves 4-6.

Honey and Pine Nut Dessert

ashṭaliyyeh

3 cups powdered milk
1 cup nasha or cornstarch
9 cups water
1 cup honey
½ cup soaked pine nuts

Mix the powdered milk and cornstarch with water. Bring to the boil stirring continuously. Reduce the heat and simmer while stirring until the mixture thickens and becomes sticky – about 2 hours. Pour into individual bowls and top with honey and pine nuts. Serves 4-6.

Semolina Dessert

smīd

5 cups milk
1 cup semolina
2 eggs
1 tablespoon butter
powdered sugar
cinnamon

In a saucepan, blend the semolina with the milk and bring to the boil. Remove the saucepan to the side. Add the eggs and melted butter and blend the mixture well. Pour the pudding into a shallow ovenproof dish and set aside to cool. Preheat the oven to 300° and bake the pudding for 15 minutes or until golden. Remove from the oven and sprinkle with powdered sugar and cinnamon. Slice and serve hot or cold. Serves 6.

Variation

Semolina Pudding

1½ cups semolina
1½ cups sugar
1½ cups milk
1½ cups water
3 tablespoons butter
1½ cups mixed nuts, (blanched almonds, walnuts and pine nuts
½ teaspoon cinnamon
1 tablespoon powdered sugar

On low heat, melt the butter and add the semolina gradually. Toast well and set aside. Mix the sugar, water and milk, and bring to the boil. Cook until the sugar is dissolved and set aside. Return the semolina to the heat and very gradually add the syrup, stirring continuously until the pudding thickens enough to coat the spoon. Pour into individual molds and set aside to cool. In a pan, melt a little butter and toss the nuts. Garnish the pudding with the nuts and sprinkle with cinnamon and powdered sugar. Serves 4-6.

Toasted Semolina with Ashta

ma'mūniyyeh

1 cup semolina
1 cups sugar
3 tablespoons butter
1½ cups water
1 tablespoon lemon juice
1 teaspoon ground cinnamon
ashta (see recipe page 134) or clotted cream

Prepare the syrup by dissolving the sugar in water. Add lemon juice and boil, stirring continuously until the syrup coats the back of a spoon. Remove to the side to cool.

Heat the butter in a pan and gently toast the semolina until well browned. Add the thick syrup and stir well. Cook for 10 minutes until it becomes thick and creamy. Spread on the *ashta*, sprinkle with cinnamon and serve the dessert warm. Serves 4-6.

Semolina Biscuits

ghrayybeh

6 cups semolina
3 cups powdered sugar
¼ cup rose water
6 cups butter
¼ cup orange blossom water

Beat the butter well until it becomes creamy. Add sugar, rose water and orange blossom water, and beat well. Gradually, fold the semolina into the mixing bowl and beat the mixture until the dough becomes smooth and pliable. Set aside for an hour until firm. Shape into any desired form such as finger or ring shapes. Place the *ghrayybeh* on a greased and floured biscuit tray and bake in a 300° oven for 15-20 minutes. The *ghrayybeh* is done when it rises and turns golden. Makes 40 biscuits.

Semolina Nut Biscuits

karabīj

6 cups semolina
1 pound butter
½ teaspoon baking soda
enough milk to form a hard dough

Sift the semolina with the baking soda. Work the butter into the semolina with your fingers until it is well mixed. Gradually add the milk to form a stiff dough.

Shape the dough into small balls the size of walnuts. Hollow and fill them with the nut filling. Close and seal. Place them on a large baking tray and bake in a 325° oven until golden. Serve with the special cream, **nātef,** on the side.

Filling:
1 cup pine nuts, coarsely ground
1 cup walnuts, coarsely ground
½ cup sugar
½ teaspoon rose water

Mix the above ingredients and use as filling.

Cream or nātef

4 cups sugar
3 egg whites
3 ounces ground halawa wood
 (bois de Panama)
1 tablespoon lemon juice

Dissolve the sugar in ½ cup water, add the lemon and bring it to the boil. Simmer, stirring constantly until it thickens into syrup. Remove to the side.

To prepare halawa wood, grind a 3-ounce piece of the white root and soak it in ½ cup cold water for 3 hours. Bring it to the boil until it foams and thickens. Strain the mixture; you should be left with one tablespoon of the mixture. Add it to the sugar syrup and stir vigorously.

Beat the egg whites stiff. Add the heavy cold syrup gradually, beating very vigorously. Use an electric mixer. The cream should become fluffy and stiff.

Serve the *nātef* with the *karabij* on the side. Makes 40 biscuits.

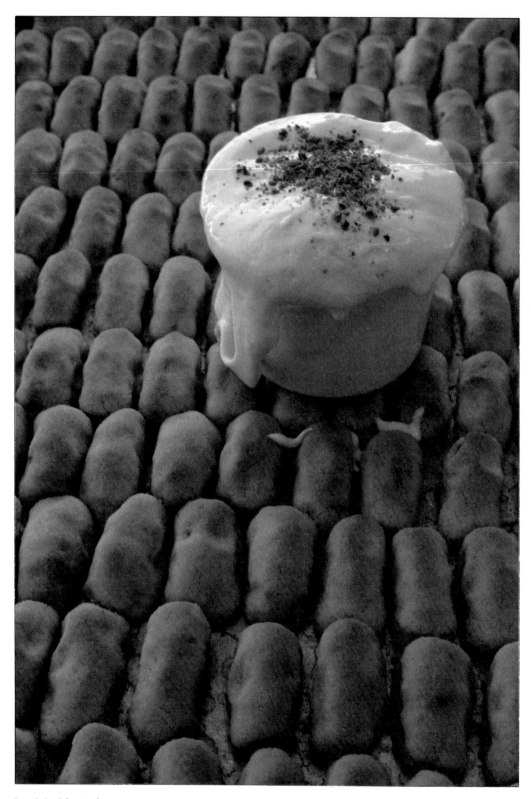

karabīj with nāṭef

Easter Walnut Biscuits

ma'mūl bi-jawz

4 pounds semolina
2 pounds unsalted butter
1 teaspoon nutmeg
2 teaspoons mahlab (see glossary)
½ teaspoon ground mistki
2 cups rose water
2 cups orange blossom water
¼ teaspoon dried yeast

Filling:
2 pounds shelled walnuts
1½ cups sugar
2 tablespoons semolina and butter mixture

Soften and cool the butter. Sift the semolina and mix well with butter. Cover and set aside overnight. The following morning reserve 2 tablespoons of the semolina mixture to be used later for the filling. Mix the orange blossom water with the rose water, add the yeast, and set aside.

Prepare the dough by kneading the semolina mixture with the spices (*mahlab*, nutmeg and *mistki*), adding the flavoring of rose water and orange blossom water gradually, until the dough is pliable. Roll the dough one tablespoon at a time into balls. Flatten it and lift the sides up to form a hollow. It is now ready for the filling.

In a food processor, grind the walnuts, add the sugar, orange blossom water and the 2 tablespoons of semolina mixture reserved from the original batch. The filling is ready.

Place one teaspoon of the filling into the hollowed dough. Close the dough over the nut mixture. Press the edges to seal well and roll into a ball.

Using the special decorated mold for the *ma'mūl*, press the ball into it to give it its traditional decorated appearance, and place each cake on a greased baking tray.

Place the tray in a preheated 325° oven and bake for 20 minutes.

Remove and cool for 10 minutes. Sprinkle with icing sugar and store in biscuit boxes. Makes 40 biscuits.

Date Rolls

ka'k bi-'ajweh

*dough according to the recipe for **Easter Walnut Biscuits***

Filling:
2 pounds dates
¼ pound butter, softened

Pit the dates and mince well in a food processor. Add the butter and blend well. Form into a long thin cord. Roll out the dough and flatten into small rectangles. Lay the date filling on one end and roll the dough into thin finger-like shapes. Cut and bring the two ends together to form a round biscuit.

Bake in a preheated 350° oven for 20 minutes. Sprinkle with powdered sugar and store in biscuit boxes. Makes 40 biscuits.

Sweet Legumes

hbūb

1 cup hulled wheat, soaked overnight
1 cup chickpeas, soaked overnight
1 cup dried small white beans or navy beans,
 soaked overnight
1 tablespoon orange blossom water
¼ teaspoon ground cinnamon or ¼ teaspoon
 anise
mixed nuts (almonds, pine nuts and
 pistachios) for garnishing

Boil the hulled wheat, chickpeas and beans separately until done. Drain and set aside. In a separate pot, dissolve the sugar in water and add the wheat, chickpeas, beans and orange blossom water. Bring to the boil uncovered. When the syrup has thickened serve hot sprinkled with cinnamon and topped with nuts. Serves 4-6.

Hulled Wheat in Syrup

amhiyyeh

2 cups hulled wheat
10 cups water
½ teaspoon anise powder
1 teaspoon orange blossom water
1 teaspoon rose water
2 cups sugar, or according to taste
½ cup blanched almonds
1 cup blanched walnuts
½ cup blanched pine nuts
1 cup seedless raisins

Soak the hulled wheat overnight. Drain, wash and cook in water until done. Add the sugar and simmer for a few minutes. Taste for sweetness, and add the orange blossom water, rose water and anise powder. Top with blanched almonds, walnuts, pine nuts and raisins and serve hot. Serves 6.

Spicy Dessert

ḥalawiyyeh

1 cup water
1 cup sugar
1½ cups whole wheat flour
2 tablespoons butter
2 tablespoons blanched chopped almonds
2 tablespoons rose water
½ teaspoon ground cardamom
1 tablespoon lemon juice

Dissolve the sugar in water, add the lemon, juice and simmer on low heat, stirring constantly, until it thickens into syrup. Melt the butter and stir in the flour until it browns. Remove it from the heat and gradually pour in the syrup, stirring rapidly. Add the almonds and return the pan to the fire. Continue to stir until the mixture thickens enough to coat the spoon. Add the rose water and cardamom. Spread the *ḥalawiyyeh* on a flat dish and garnish with whole almonds. Serve cold. Serves 4.

Lebanese Fruit Cake

kayk

1½ cups powdered sugar
5 eggs
1 tablespoon butter
2 cups ashta or clotted cream
1 cup wheat germ
1 cup mixed dried fruits (apricots, figs,
 prunes), diced
1 cup seedless raisins

Beat the eggs well and add the remaining ingredients. Blend well. Place the mixture in a pan lined with heavy wax paper. Place the cake pan in a shallow pan filled with one inch of water and bake at 300° for one hour or more. Serves 6.

Lebanese Doughnuts

'awwāmāt

2 cups flour
1 cup laban
¼ teaspoon yeast
¼ teaspoon salt
water enough to make a soft dough

Dissolve the yeast in a little warm water. Add the *laban* and flour and beat well with an electric mixer at medium speed. Add water gradually and continue beating until the dough is smooth and of a creamy consistency. Do not over beat. Cover and set aside to allow the batter to rise. Drop by the teaspoonful in deep hot oil. Brown the doughnuts on all sides until lightly golden. Drain on absorbent paper. Finally, coat the doughnuts with hot syrup, (recipe page 134) and serve. Makes 25 doughnuts.

Potato Doughnuts

'awwāmāt bi-baṭāṭa

1 cup flour
⅔ cup mashed potatoes
¼ teaspoon yeast
2 cups water
⅛ teaspoon salt
oil for deep frying

Dissolve the yeast in a little warm water. Mix the potatoes with the flour. Add the yeast and knead, adding water gradually until the dough is smooth. Set aside to rise.

Prepare the syrup:
1 cup sugar
½ cup water
1 teaspoon lemon juice
1 teaspoon orange blossom water

Dissolve the sugar and bring to the boil stirring continuously. Reduce the heat and add the lemon and orange blossom water. Simmer until the syrup thickens enough to coat a spoon.

Drop the dough by the teaspoonful into the hot oil. When doughnuts rise to the surface, remove to absorbent paper to drain. Dip them in the syrup and serve warm or cold. Makes 25 doughnuts.

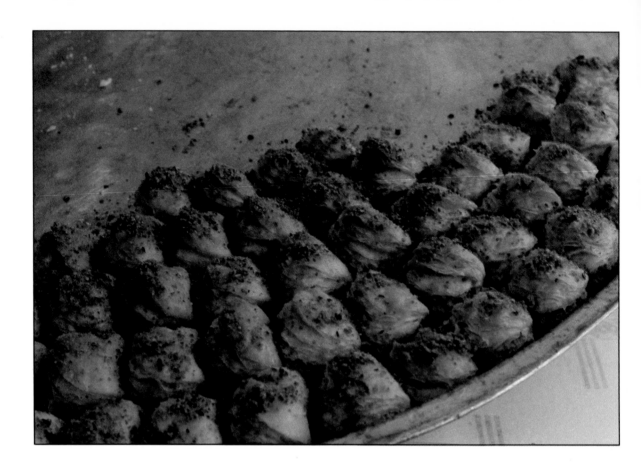

Pine Nut Pastry

kol wa shkor

1 pound fillo pastry
1½ cups samneh
½ cup crushed pine nuts
1½ teaspoons orange blossom water
2 cups sugar
1 tablespoon lemon juice
1 teaspoon rose water
crushed pistachio nuts for garnishing
1½ cups water

Cut the fillo pastry into 10-inch squares. Lay the pastry squares flat on a table top. Lay a row of crushed pine nuts along one end and cover with the dough to a width of 2 inches.

With a small biscuit cutter, the size of a thimble, cut out the filled end of the pastry into individual pieces. Remove the tiny bite-size filled pastry to a greased baking tray. Remove the excess pieces of pastry and crumble over the rest of the squares. Repeat the process and continue cutting with the biscuit cutter until the tray is filled.

Heat the *samneh* and brush the pastry biscuits evenly. Bake the pastry at 350° in a preheated oven for 45 minutes or until golden.

Prepare the syrup by dissolving the sugar in water with lemon juice, rose water and orange blossom water. Bring to the boil stirring frequently until the syrup thickens. Sprinkle on the pastry while hot. It should puff up immediately. Sprinkle the crushed pistachio nuts and set aside to cool. Makes 40 pieces.

Shredded Pastry with Cheese

knēfeh

2 pounds knēfeh pastry (see glossary)
2 pounds white akkawi cheese or Italian ricotta cheese
1 cup samneh
syrup according to the recipe on page 134

Sweeten the cheese by slicing it thinly and covering it with warm water for 2 hours. Change the water at least once.

Grease a large baking tray with *samneh*. Rub the remaining *samneh* into the pastry. Spread the *knēfeh* evenly in the tray using wax paper to press it down and smooth it out.

Lay the cheese over the *knēfeh* in the tray. Sauté the *knēfeh* on top of the stove on very low heat, turning the tray continuously to brown evenly. To find out if it is done, hit the side of the tray against the stove. When the *knēfeh* is ready it lifts in one single piece. Meanwhile, blot out with a paper towel any excess water that forms on the surface of the cheese. Flip the *knēfeh* over into another greased tray. Now the cheese is on the bottom. Return the tray to the heat for 3 minutes to melt the cheese further. Sprinkle some of the syrup all over the pastry. Serve hot with more syrup on the side. Serves 6-8.

Shredded Pastry with Nuts

burma

1 pound shredded knēfeh pastry, (see glossary)
½ pound chopped nuts or pine nuts
1 cup syrup, see recipe on page 134
1 cup melted margarine

Rub the pastry with melted margarine. Lay the threads of pastry very close together on a clean surface. Arrange the pistachio or pine nuts filling along it diagonally. Place a skewer along the corner of the pastry and cover with the pine nuts or pistachios. Roll the pastry diagonally over the skewer very tightly in the form of a thick sausage. Gently pull out the skewer leaving the filling inside the roll. Lay the long pastry roll on a greased tray and continue to fill the remaining pastry until it is all used up. Place a tray on top of the rolls and press down with a heavy weight. A pan filled with water will serve. Set aside for one hour to prevent unrolling.

Meanwhile, prepare the syrup according to the recipe on page 134.

Cover the rolls of pastry with the melted butter and brown on medium heat turning the tray continuously. To brown the other side, place a greased tray on top of the rolls and flip them over. Brown the other side. Drain the excess grease and pour on the cooled syrup. Cut the long rolls into 1½-inch individual portions and serve cold. Serves 6-8.

Shredded Pastry with Ashta

'usmalliyyeh

2 cups ashta (page 134)
2 cups syrup (page 134)
1 pound knāfeh pastry (see glossary)
1 cup margarine, melted

Loosen the *knāfeh* pastry by pulling it gently apart. Do not chop it. Spread it out evenly on a large greased baking tray. Cover with the melted margarine.

Sauté the pastry on medium heat on top of the stove, turning the tray continuously to brown evenly. Drain excess grease and set aside. Prepare another tray of pastry for the top layer. Spread the *ashta* on one pastry layer and top with the second layer of pastry. Sprinkle on the cold syrup and serve immediately. Serves 4-6.

Farina Pastry with Pine Nuts

sfūf

2 pounds farina
2 pounds sugar
1½ cups butter, or olive oil
2 tablespoons turmeric
3 teaspoons baking powder
2½ cups milk
pine nuts

Sift the farina with the baking powder and turmeric and set aside. Melt the butter and rub it into the sugar. Gradually add the milk and flour and mix well until the dough is smooth. Spread on a greased baking tray. Top with pine nuts and bake in the oven at 350° until lightly browned. Cool and slice into individual portions. Makes 24 portions.

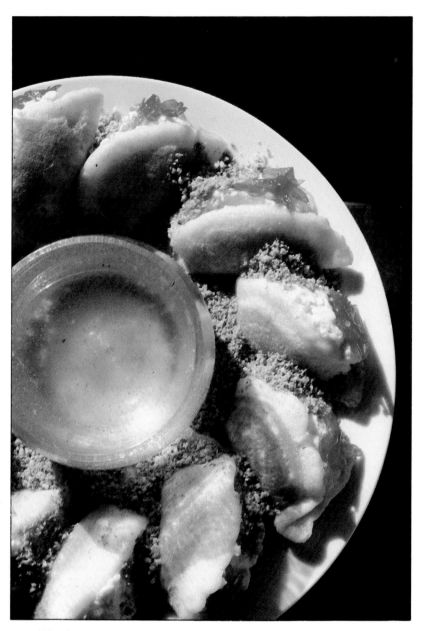

aṭāyef bi-ashṭa

Pancakes Filled with Ashta

aṭāyef bi-ashṭa

2 cups flour
1½ cups warm water
1 teaspoon sugar
2 teaspoons dried yeast
pinch of salt
syrup (page 134)
ashta for the filling (page 134)

Dissolve the yeast in ¼ cup warm water, add the sugar and set aside. Sift the flour and salt into a warmed bowl. Make a hole in the center and pour in the remaining water and the yeast. Stir until well blended and smooth. Cover the bowl with a cloth and set it aside in a warm place for one hour, or until the batter has risen and is bubbly.

Heat a pan and grease it with a cloth dipped in oil. Using a ladle, pour in about 2 tablespoons of batter and tilt it to spread the batter into a fat round – about 4 inches in diameter. Cook until it is golden brown on the underside and lifts from the pan easily. Do not brown the other side. Lift the pancakes to a side dish. Continue until all the batter is used up. Put one tablespoon of *ashta* on the unbrowned side of each pancake and fold in half into a crescent shape. Pinch the edges together firmly to seal. Serve with syrup on the side. Serves 6.

Variation

Fried Atayef Filled with Walnuts

aṭāyef bi-jawz

Filling
1 cup chopped walnuts
3 tablespoons sugar
1 teaspoon cinnamon
oil for deep frying

Mix the nuts, cinnamon and sugar and stuff the pancakes. Heat the oil and deep fry. Serve hot with syrup.

Sweet Potato Dessert

baṭāṭa ḥelweh

4 *sweet potatoes, boiled and mashed*
1 *cup ashta (page 134)*
¼ *cup milk*
1 *cup sugar*
½ *cup sugar*
½ *cup water*
1 *teaspoon lemon juice*
2 *tablespoons butter*

Blend the butter with the mashed sweet potatoes and milk. Spread the mixture in an ovenproof dish. Bake for 5 minutes at 425°. Meanwhile, prepare the syrup by dissolving the sugar in the water. Bring to the boil stirring continuously. Add lemon juice and simmer until the syrup thickens enough to coat a spoon.

Spread the *ashta* over the still warm mashed potatoes and pour on the syrup.

Serve immediately. Serves 4-6.

Powdered Orchis Bulb Pudding

sahlab

2 *cups milk or water*
2 *teaspoons sahlab (see glossary)*
3 *tablespoons sugar*
½ *teaspoon cinnamon*

Bring the milk or water to the boil, add the *sahlab* and sugar stirring continuously, until the mixture becomes gelatinous.

Sprinkle with cinnamon and serve hot with sesame bread on the side. Serves 2.

Prunes with Cream

khokh bi-krēma

1 *pound prunes*
1½ *cups heavy cream*
2 *drops vanilla extract*
brewed tea
1 *tablespoon lemon juice*
1 *cup water*
2 *tablespoons sugar*
walnuts

Soak the prunes in the hot brewed tea overnight. Drain, remove the pits, and replace them with walnuts.

Bring the water, sugar and lemon juice to the boil. Drop in the stuffed prunes and simmer for 20 minutes.

Cool and place them in a transparent glass bowl.

Whip the cream until stiff, and add vanilla and sugar to taste.

Scoop the cream into the serving bowl to smother the prunes. Chill and serve. Serves 4.

Dried Fruit Salad

khshēf

½ pound dried apricots, soaked overnight
½ pound dried prunes, pitted and soaked
 overnight
½ pound small seedless raisins, soaked
 overnight
1 cup sugar
4 cups water
1 teaspoon orange blossom water
1 cup mixed nuts (almonds, pine seeds,
 walnuts and pistachios), soaked separately

In a mixing bowl, dissolve the sugar in
water and add the flavoring, soaked dried
apricots, prunes and raisins. Add the nuts
to the fruits in the mixing bowl, chill and
serve in a punch bowl. Serves 6.

Dried Fruit Dessert

n'ū'

¼ pound dried apricots, soaked overnight
¼ pound dried pitted prunes, soaked overnight
¼ pound seedless raisins, soaked overnight
¼ pound dried figs, soaked overnight
½ cup sugar
½ cup mixed nuts, soaked and peeled
 (almonds, walnuts, pistachios and pine
 nuts)

In a saucepan dissolve the sugar in water
and boil for 5 minutes. Drop in the dried
fruits and boil for 15-20 minutes longer or
until the syrup thickens. Blend in the mixed
nuts and allow the dessert to simmer for 5
minutes longer. Pour into individual molds
and refrigerate. Just before serving, top with
whipped cream. Serves 4-6.

Moist Coconut Biscuits

hrīseh

3 cups farina
2 cups coconut
2-2½ cups milk
1 cup butter
2 teaspoons baking powder
½ cup almonds, blanched and separated into
 halves

Mix the farina, coconut and baking powder.
Add milk and set aside for 10 minutes. Melt
and add the butter. Blend the ingredients
well to form a dough. Grease a baking tray
using oil and spread the dough in it. With a
sharp knife slice it into 1½-inch squares.
Top with almonds and bake in a 350° oven
for one hour. Prepare the syrup according
to the recipe on page 134. Cool before
pouring over the hot tray of dessert. Serve
the individual squares cold. Serves 6.

Arabic Ice Cream

būza 'arabiyyeh

2 tablespoons sahlab (see glossary)
3 cups milk
1 cup heavy cream
1 cup sugar
¼ teaspoon ground mistki
1 tablespoon orange blossom water
crushed unsalted pistachio nuts

Dissolve the *sahlab* in a little cold milk.
Dissolve the sugar in the rest of the cold
milk and add the cream. Bring to the boil.
Slowly, blend in the dissolved *sahlab*,
stirring constantly. Stir in the *mistki* and
simmer very gently over low heat stirring
constantly for about 10 minutes. Add the
orange blossom water and remove from the
heat. Beat well with a wooden spoon and
pour into the freezer trays. Cover and
freeze.

Beat the ice cream with a wooden mallet
on a marble or wooden slab, until it is
elastic and smooth. Chill. Repeat the
procedure several times. Serve sprinkled
with crushed pistachio nuts. Serves 4.

Peanut Clusters

fist'iyyeh

1 pound raw peanuts
1½ cups sugar
1 cup water

Dissolve the sugar in water, add the
peanuts and bring to the boil stirring
continuously, until the sugar becomes
caramelized. Pour immediately into a
greased tray. Smooth with the back of a
spoon. Cool and cut into small bite-size
portions. Makes 20 portions.

Coffee

ahweh

Coffee may be served *murrah* (bitter),
mazbūta (regular) or *hilweh* (sweet). The
following is the recipe for *mazbūta* (regular).

1¼ cups cold water
1 heaped teaspoon ground Arabic or Turkish
 coffee
1 level teaspoon sugar
a few drops of orange blossom water (optional)
a pinch of ground cardamom (optional)

Using the traditional Lebanese *rakweh* or
coffeepot, dissolve the sugar in the water
and bring to the boil. Add the coffee and
stir well and bring back to the boil. When
the foam rises to the top, remove the
coffeepot from the heat to allow the foam to
subside. Return the pot to the heat and
bring to the boil again. Serve in individual
demitasse cups with a few drops of orange
blossom water (optional) as added flavoring.
Ground cardamom is added to the coffee
beans before brewing.

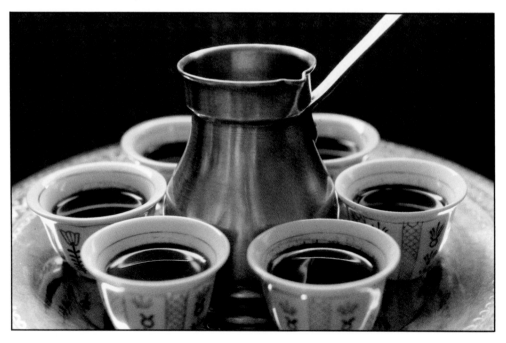

Glossary and General Information

Allspice—The purplish black berries of a tree that grows in South and Central America. Ground, it has a flavor very similar to the spice blend **bhar,** and is often substituted for it.

Ambarīs—A curd cheese made of a mixture of goat's milk and cow's milk, which takes 7 months to mature (page 45).

Aniseed—*yansūn*—The seeds of the aromatic fruit of a small wild or cultivated annual plant, which are used to flavor cakes, breads and the local spirit *arak.* Brewed, they are drunk as a medicinal tea to soothe indigestion.

Arak—The local Lebanese spirit distilled from grapes and mixed with anise. The grapes are crushed and left to stand for 20 days in a large iron barrel. The juice is then distilled several times to extract the alcohol. Anise is added the last time around and the resulting spirit is *arak.* To every 6 parts of alcohol add one part of anise.

Arīsheh—A dry ricotta cheese eaten plain with honey or sprinkled with sugar (see recipe page 44).

Artichokes—*ardishawki*—A bud of the glorified thistle, which

used to grow wild in Lebanon. Nowadays, it is cultivated and has become a delicious vegetable often stuffed with other vegetables. Wash artichokes, trim them with scissors when using them whole. When using the hearts only, remove the leaves and the inner choke by scraping with a knife and scooping it out with a spoon. Since artichokes discolor easily, always place them in acidulated water until you are ready to use them.

Ashta—Clotted Cream—(see page 134).

'Ayrān—A refreshing drink usually made from 2 parts beaten laban to one part water. It is salted and garnished with fresh mint leaves or sprinkled with crushed dried mint leaves. Recipe page 43.

Bay Leaf—*warak al-ghār*—A herb that is native to the Mediterranean and often used in soups, sauces and stews.

Beans, Broad—*fūl*—Also known as fava beans, broad beans are one of the most ancient of vegetables to be found in the East. They have been regarded with respect since time immemorial. Broad beans are rich in protein. Cooked fresh complete with

pod, shelled and cooked, or dried, they are an important item in the Lebanese cuisine.

Beans, Green—*lībiyeh*—There are many varieties in Lebanon, most common of which are the snap beans and the French beans. In all cases, when they are young, they should be cooked whole. To prepare them for cooking, top, tail and string them.

Beets—*shmandar*—Both beet roots and beet tops are used by the Lebanese. Beet leaves or tops are used like spinach or other leaf vegetables. Beet roots must not be skinned or trimmed before cooking to prevent bleeding. Allow 30 minutes of cooking time for the fresh variety.

Bhar—A spice blend made of cloves, cinnamon and nutmeg. It is very similar in flavor to allspice (see above), which may be substituted for it.

Brine—Pickling salty water (see page 23).

Burghul—Hulled wheat, also known as bulgar, cracked in a long process of poaching, drying and grinding (see page 17).

Cabbage—*malfūf*—A vegetable eaten all over the world for

thousands of years. The variety most used in Lebanon is the white cabbage, although both the red and green are available. It contains iron, and vitamins A, B and C. To prepare, remove the stalk and outer wilted leaves. Strip the leaves and remove the tough central rib and proceed to shred or stuff according to the recipe.

Chamomile—*babūnij*—An annual plant with small, white daisy-like flowers, found on the fringe of wheat fields. It is taken as a tisane to aid digestion. It is also thought to have a disinfectant effect, and as an herbal hair rinse, to lighten hair.

Cardamom—*habb al-hāl*—A member of the ginger family found in India and cultivated in other tropical areas. Its seeds are used to flavor coffee and some desserts. The seeds are sold in their pods, which are green or bleached white.

Carrots—*jazar*—The variety available in Lebanon is small, tapering and bright in color. Whenever possible do not pare or scrape carrots; their flavor and nutritive elements are close to their skins. Carrots are rich in vitamin A, and also contain vitamins B, C and E. Simply scrub, top and tail them.

Cauliflower—*arnabīt*—Contains vitamins A, E and a lot of C. It is also rich in potassium and phosphorous. In Lebanon, cauliflower is firm, white and medium in size. Before using, cut off all the outer leaves, divide the cauliflower into separate florets, and wash them well in cold water.

Celery—*karafs*—A vegetable said to have been introduced to the Lebanese by the Romans. Today it is not as common as it seems to have been in the past, and when it exists it is thought to be Italian. As a tisane, it is recommended by our grandmothers for sufferers of rheumatism. It is mostly served raw or as a flavoring agent.

Chickpeas—*hummus*—A very popular legume in Lebanon and in the rest of the Middle East. Chickpeas must be soaked overnight before being cooked. To skin them, rub them between the palm of the hand or press them with a wooden rolling pin. A favorite way of cooking chickpeas is to mix them with tahini, garlic and lemon juice in the famous dip, **ḥummuṣ bi-taḥīni.**

Cinnamon—*irfeh*—The dried inner bark of the cinnamon or cassia tree. It is an essential ingredient in the Lebanese spice blend bhar. It is used either as a piece of bark or ground.

Cloves—*kibsh 'runful*—A native of the Spice Island. As a spice, it is versatile and contributes to every part of the menu. It is also one of the essential ingredients of the spice blend *bhar*.

Coriander—*kuzbra*—An annual plant in the umbelliferous family, also sold in Oriental and Latin markets as cilantro. Its fresh leaves are used much as parsley leaves. Its seeds are highly aromatic. Mixed with garlic it is a favorite flavoring of the Lebanese.

Cucumber—*khiyār*—The variety in Lebanon is small and firm. The cucumber dates back to the Romans. It is not known to have a great deal of nutritive value, only a small amount of vitamin C. In Lebanon it remains a favorite and is eaten raw, cooked or pickled.

Cumin—*kammūn*—The seeds are a tantalizing seductive spice. Native to the Nile Valley, cumin is used by the Lebanese in many dishes.

Cumin, Black—*habb al-barakeh*—A small aromatic seed that is used to flavor **hallūm** cheese. It bears no relationship to the above cumin.

Dandelion Greens—*hindbeh*—Sold in large quantities in Lebanon. Wild or cultivated, they are eaten raw or cooked. These leafy vegetables or herbs supply an abundance of vitamin B and C and an assortment of alkaline salts, which are a good purifying agent for the body. They are also thought to promote healthy circulation of the blood and to cleanse the skin.

Dibs Kharrūb and 'Inab—Molasses made from the carob pod (*kharrūb*) or from grapes (*'inab*). It is mixed with tahini and served with flat bread as a snack, for breakfast, or after meals to replace dessert.

Dibs Rummān—Molasses made from the seed of the sour pomegranate available outside the Middle East countries in gourmet stores. It is widely used in salads and cooked dishes (see page 31).

Eggplant—*bātinjān*—Eggplant, also known as aubergines, were brought from India to the Mediterranean. The Lebanese boast a profusion of recipes but only a few fundamental cooking methods. In addition to the large pear-shaped variety found in Europe, the most popular eggplants found in Lebanon are the small egg-shaped variety about 2-3 inches long, which are cooked whole.

The most important step in preparing eggplant for cooking, is to salt the flesh and let it stand for at least half an hour, to drain its bitter juices. Proceed to fry, stew or stuff. To skin it for mashing, sear it in a very hot oven or over high heat until the skin blisters. Remove the skin under cold running water, seed, and proceed to dress it with any of the variety of dressings listed in the recipes.

Endive—A tightly rolled parcel of blanched fleshy leaves. Its ancestor is the curly lettuce-like green known as chicory. In Lebanon, the curly variety is used in salads and its descendant, the small bunch-like endive, is served either cooked or raw. When cooked, endive must be blanched for 3 minutes in boiling water to remove all bitterness. Since it discolors quickly, cut it just before using it.

Fatayer—Small triangular pies with a variety of fillings (spinach, purslane or chard) made from bread dough mixed with olive oil.

Fennel—*skummar*—May be eaten raw or cooked when the base of the stalk is enlarged and bulbous, or used as flavoring when it is thin and feathery. It is thought to engender sleep.

Feta Cheese—A Greek crumbly goat cheese. It may be substituted for the white Lebanese cheese when indicated in certain recipes.

Fillo Pastry—Tissue thin pastry, rolled and filled with a variety of fillings. Fillo is found commercially in most supermarkets. Keep fillo layered with wax paper and covered with a dampened cloth in the refrigerator.

Garden Rocket—*rocca or jarjīr*—A salad herb that grows almost anywhere in Lebanon. Its pungent-tasting leaves are excellent in a salad, alone, or mixed with other leaf vegetables and herbs.

Garlic—*tūm*—A member of the lily family with an extraordinary capacity to season food. It is one of Lebanon's most-used plants. In addition, all kinds of cures are attributed to it.

Grapevine Leaves—*wara' 'inab*—The tender fresh leaves of the grapevine, which are eaten fresh and raw with **tabbūleh,** or cooked, stuffed with rice and herbs. Vine leaves are often preserved for use in winter by pickling them in brine.

Ḥallūm—White cheese, matured in whey and sometimes flavored with black cumin seed (see page 44).

Kibbeh—The term applies to a mixture of pounded cracked wheat with meat, or fish or vegetables and minced onion. This book is only concerned with vegetable kibbeh.

Kishk—Burghul fermented with laban dried in the sun and ground. It is available in Middle East food stores.

Knēfeh Dough—a highly specialized art. The preparation of this dough is almost always left to the specialists in the sweetmeat shops. The following is a home version of it and is quite acceptable if the original is unavailable.
2 pounds top quality white flour
1½ cups water
1 cup milk
¾ cup butter
Sift the flour, blend in enough water and the milk and knead well to obtain a smooth dough. Proceed to thin the dough by adding more water until it has the consistency of pancake batter. Heat a skillet and drop the dough through the holes in a colander onto the heated skillet. The batter should drop in the form of strings that solidify on contact with heat. Continue the process until all the batter has been treated in this way. Melt the butter and pour it over the *knēfeh* strings. Cool and grind it in a meat grinder. Refrigerate for later use.

Laban—*yogurt*—(see page 42).

Labneh—A *laban* cream cheese (see page 43).

Lettuce—*khass*—The Romans are said to have eaten lettuce as a cure for all ills. It is very popular in Lebanon and is

consumed in large quantities. The Romaine variety is the most common.

Maḥlab—The ground or whole kernel of the black cherry tree that grows in Syria. It is used to flavor breads and cakes.

Marjoram—*mardakūsh*—A descendant of the mint family native to Asia. It is a versatile herb with a sweet spicy flavor. Its fresh leaves are used in omelettes and in *kibbeh*.

Marqūq Bread—Paper thin bread sheets that are a speciality of rural Lebanon (see page 16).

Mezze—A traditional Lebanese variety of hors d'oeuvres served in small portions – 20 or more at a time. Mezzes include such dishes as **hummus bi-tahini, mtabbal, fried and grilled hallūm cheese, labneh, parsley salad, mhammara, fatāyer, sambūsek, tabbūleh, fūl mdammas, thyme** and **rocca salads, pickles, olives, sliced tomatoes** and many many more. Bite-size pieces of the flat bread are used to scoop up the food directly from the small serving plates. *Arak* is the alcoholic drink traditionally served with mezzes.

Mlūkhiyyeh—An Egyptian herb known as Jew's mallow, which has the viscous property of okra. Outside the Middle Eastern countries, where it is unavailable fresh, *mlūkhiyyeh* can be found in its dried form in Greek and Middle Eastern stores.

Mnā'ish—A bread dough that

is spread with a variety of herb mixtures and baked (see pages 130).

Mistki—A resin from a small evergreen tree that grows in the Mediterranean and especially on the Island of Chios in Greece. It is often chewed as gum with a pinch of candle wax to soften it, or used in ice creams and desserts as flavoring.

Mighlī—A pudding made of ground rice and spices, traditionally served to honor the birth of a child. Whole dishes of this pudding are offered to relatives and neighbors to celebrate the happy event.

Mushrooms—*fitr*—A fungi rich in potassium and phosphorus and very low in calories. They are best when fresh and should be eaten freshly gathered.

Mint—*na'na'*—One of the oldest culinary herbs to be used in the Mediterranean. The most common variety in Lebanon is spearmint. It is used in food and as a tea to aid digestion.

Nutmeg—*jawz al-tīb*—A tropical island plant that is also an essential ingredient in the spice blend *bhar*, so valuable to the Lebanese cook.

Okra—*bāmijeh*—An annual of the edible Hibiscus mallow family, believed to have originated in Ethiopia. Cook okra in stainless-steel pots, never in brass or iron, since the resulting chemical reaction will discolor the pods. Cook it

rapidly to overcome pastiness and do not overcook.

Onion—*basal*—Prized for its flavor by the Ancients, held sacred by the Egyptians, and cultivated by the Romans and Greeks alike. It is the most necessary food item in the kitchen, and used both as seasoning and as a vegetable. There are many varieties of onions grown in Lebanon. Spring or green onions are a common variety eaten fresh in salads. But for cooking purposes onions are better when used fully grown, when they have brown or yellow skins. The variety with purple-tinged flesh is sweet and excellent when eaten raw.

Orange Blossom Water—*mazahr*—Distilled from the blossoms of the bitter orange tree, the water is drunk as an infusion and known as white coffee. It is also added to sweets and desserts as flavoring.

Parsley—*ba'dūnis*—Nature's own vitamin pill (rich in vitamins A, B and C). It originated in the eastern part of the Mediterranean and from there it spread all over the world as a garnish. Only the flat leaf parsley is used in Lebanon where it is looked upon as much more than a garnish; it stands on its own. It is thought to have a favorable effect on the liver and the urinary system.

Peas—*bāzellā*—A well known vegetable to the early Lebanese. The most common variety is the round garden pea. Peas are rich in proteins

and carbohydrates and contain vitamins A, B and C. Cook in very little water and for 5 to 10 minutes only.

Peppers—*flayfleh*—They come in all shapes, sizes and colors. As a general rule the larger the variety the sweeter it is. Peppers contain vitamins A, C and B. Always seed the peppers before using them.

Potato—*batāta*—It has a long and complicated history. Many people have been credited with its introduction from its native South America. The fact is that in Lebanon it has become a regular item in the diet. It is one of the most valuable and nutritious of vegetables. It contains vitamins B and C as well as carbohydrates.

Radishes—*fijl*—A vegetable that is both decorative and delicious. It exists in all its varieties in Lebanon, but the button radishes are the most popular. They are eaten sometimes with their greenery, alone or in salads.

Raisins—Grapes treated with lye water and dried on the rooftops of houses. The process involves soaking the grapes in the lye solution and leaving them to dry. Lye water is sprinkled daily until the grapes become raisins. They are used in desserts or alone with nuts as a snack.

Rishta—A form of tagliatèlle Italian macaroni. In the absence of the homemade rishta, Italian macaroni may be substituted.

Rose—*ward jūri*—The Damask

or eglantine rose petals used to make distilled rose water, jams or candied as decorations for desserts such as *atāyef* (page 148). Dried rose hips are used to make potpourri.

Rosemary—*iklīl al-jabal – 'aytrān*—A powerful herb, pungent and piney. It grows wild in spring and has historical associations with the Virgin Mary. It is used at weddings as a strewing herb.

Rose Water—*māward*—Distilled from the petals of the Damask or eglantine rose and used in sweets and desserts or as a tisane. It is available outside the Middle East in the form of concentrated essence in pharmacies, or as water in gourmet stores.

Sage—*as'īn*—One of the old favorite herbs famous for its healing properties. It is digestive, soothes the nerves and aids the circulation. It is also known to reduce fever by producing free perspiration. Rural people still use it as an astringent to cleanse wounds.

Sahlab—A powder extracted from the dried roots of the orchis. It is made into a hot beverage sprinkled with cinnamon or used to thicken *būza* or Arabic ice cream.

Sambūsek—Half-moon pastry filled with a variety of stuffings (see page 13).

Samneh—Clarified butter that can be heated to high temperature without burning.

Srīra/Sraysīra—The fine

powder-like remnant from the grinding of burghul. It is not available commercially and may be replaced by very fine burghul or ground whole wheat.

Sharāb—A syrup concentrate of fruit juices bottled and preserved. It is diluted according to taste with cold water and ice cubes and served as a refreshing drink.

Semolina—*smīd*—Granular wheat flour available in gourmet shops. Cream of wheat flour may be substituted.

Snūbar—Pine nuts: the nuts from the kernels of the umbrella pine tree. They are used freely in Lebanese foods and desserts.

Spinach—*sbēnekh*—A leafy vegetable that turns up almost everywhere in Lebanon. Spinach is best when eaten young and fresh. It is high in calcium, iron and vitamin C. Cook spinach in its own juices. The Lebanese have a variety of ways to dress up spinach.

Sumac—*summā'*—The berries of a species of the sumac tree that have a sour lemony taste. Crushed, they are used in the local bread salad, or when soaked their juices are added to potatoes and other vegetables.

Swiss Chard—*sil'*—A variety of spinach with enormous leaves and broad silver mid-ribs.

Tahīni—Sesame paste made

from toasted sesame seeds. It is highly prized in Lebanon. Toasting sesame seeds enhances their crisp nut-like flavor. Tahini can be bought outside the Middle Eastern countries in gourmet stores, health food stores or Greek or Lebanese groceries. To make your own tahini, heat a cast-iron skillet and toast a cup of hulled sesame seeds. Toss the seeds until they are well roasted. Place them in a blender with one tablespoon of water and blend. Add water until the paste is thick but creamy. Store in a jar standing upside down to prevent the paste from separating.

Taro—*il'ās*—A large starchy tuber treated like potatoes. Its botanical name is colocasia esculenta.

Thyme—*za'tar*—A spreading evergreen perennial with little mauve flowers that blooms in summer. It is used in food as a flavoring or mixed with *sumac*, sesame seeds and olive oil and eaten with flat Arabic bread for breakfast, (see **za'tar**).

Tisane—A refreshing herbal tea made from fresh or dried leaves, flowers, petals, or crushed seeds. Use 3 tablespoons of fresh herb or one tablespoon of dried, pour on 2½ cups of boiling water, cover closely and let stand for 5 minutes. Strain and use hot. The tisane is sometimes sweetened with sugar or honey.

Turmeric—*'i'deh safrā*—A dried fleshy root of the ginger family. It is similar to saffron both in color and in its clean bitter flavor. It is used for both these qualities in certain desserts.

Turnips—*lift*—A root which when small is almost always used to make pickles. Turnips are high in essential mineral content and low in vitamins.

Vervain, Lemon Verbena— *mallīsa*—A herb drunk as a tisane, thought to be effective against fever and colds. It is considered a tonic for the entire system.

Watercress—*rashad*—A herb that grows quickly and is available in the winter and spring months. It contains a valuable source of iodine. The Lebanese do not look upon it merely as a decorative garnish; it is eaten raw with bread, cheese and olives or dressed in salads. Watercress is rich in vitamin C and organic minerals. The Lebanese believe it delays the aging process and stimulates the digestion.

Za'tar—A mixture made of 2 cups of crushed dried thyme leaves, one cup *sumac*, ½ cup sesame seeds and one tablespoon salt. These ingredients are mixed with olive oil and served with flat bread, or spread on bread dough and baked.

Zucchini—*kūsa*—A vegetable that has always existed in South and Central America. In Lebanon it is eaten when small. It contains vitamins B and C.

Index

Index of Recipes and Ingredients in Arabic

Where to Find Ingredients

Arizona

Hajji Baba Middle Eastern
 Food
1513 East Apache
Tempe, AZ 85281

California

Levant International Food Co.
9421 Alondra Blvd.
Bellflower, CA 90706

Sunflower Grocery & Deli
20774 E. Arrow Hwy.
Covina, CA 91724

Eastern Market
852 Avocado Ave.
El Cajon, CA 92020

Fresno Deli
4627 Fresno St.
Fresno, CA 93726

M & J Market & Deli
12924 Vanowen St.
North Hollywood, CA 91605

K & C Importing
2771 West Pico Blvd.
Los Angeles, CA 90006

Fairuz Middle Eastern Grocery
3306 N. Garey at Foothill
Pomona, CA 91767

International Groceries
 of San Diego
3548 Ashford St.
San Diego, CA 92111

Samiramis Importing Co.
2990 Mission St.
San Francisco, CA 94110

Middle East Food
26 Washington St.
Santa Clara, CA 95050

Sweis International Market
6809 Hazeltine Ave.
Van Nuys, CA 91405

Colorado

Middle East Market
2254 S. Colorado Blvd.
Denver, CO 80222

International Market
2020 South Parker Road
Units A & B
Denver, CO 80231

Connecticut

Shallah's Middle Eastern
 Importing Co.
290 White St.
Danbury, CT 06810

Florida

Damascus Imported Grocery
5721 Hollywood Blvd.
Hollywood, FL 33021

Ali Baba Food, Inc.
2901 West Oakland Park Blvd.
Fort Lauderdale, FL 33311

Georgia

Leon International Foods
4000-A Pleasantdale Rd., N.E.
Atlanta, GA 30340

Middle Eastern Groceries
22-50 Cobb Parkway
Smyrna, GA 30080

Illinois

Holy Land Bakery & Grocery
4806-8 N. Kedzie Ave.
Chicago, IL 60625

Middle Eastern Bakery &
 Grocery
1512 W. Foster Ave.
Chicago, IL 60640

Maryland

Dokan Deli
7921 Old Georgetown Rd.
Bethesda, MD 20814

Yekta Deli
1488 Rockville Pike
Rockville, MD 20800

Massachusetts

Syrian Grocery
270 Shawmut Ave.
Boston, MA 02118

Lebanese Grocery
High Point Shopping Center
4640 Washington St. #4-3
Roslindale, MA 02131

Near East Baking Co.
5268 Washington
West Roxbury, MA 02132

New York

Oriental Grocery
170-172 Atlantic Ave.
Brooklyn, NY 11021

Sahadi Importing Co.
187 Atlantic Ave.
Brooklyn, NY 11201

Nadar Import
One East 28th St.
New York, NY 10016

Sunflower Store
97-22 Queens Blvd.
Rego Park, NY 11374

Nablus Grocery
456 S. Broadway
Yonkers, NY 10705

North Carolina

NUR, Inc.
223 Avent Ferry Road #108
Raleigh, NC 27606

Ohio

Gus's Middle Eastern Bakery
308 East South Street
Akron, OH 44311

Middle East Foods
19-57 West 25th St.
Cleveland, OH 44113

Sinbad Food Imports
2620 N. High St.
Columbus, OH 43202

Holy Land Imports
12831 Lorain Avenue
Cleveland, OH 44111

Oklahoma

Mediterranean Imports &
 Health Foods
36-27 North MacArthur
Oklahoma City, OK 73122

Michigan

The Arabic Town
16511 Woodward
Highland Park, MI 48203

Minnesota

Cindybad Bakery & Deli
1923 Central Ave., N.E.
Minneapolis, MN 55418

Missouri

Campus Eastern Foods
408 Locust Street #B
Columbia, MO 65201

New Jersey

Fattal's Syrian Bakery
977 Main St.
Paterson, NJ 07503

Nouri's Syrian Bakery &
 Grocery
983-989 Main St.
Paterson, NJ 07503

Al-Khayam
7723 Bergenline Ave.
North Bergen, NJ 07047

Pennsylvania

Makhoul Corner Store
448 N. 2nd St.
Allentown, PA 18102

Bitar's
947 Federal St.
Philadelphia, PA 19147

Salim's Middle Eastern
 Food Store
47-05 Center Ave.
Pittsburgh, PA 15213

Texas

Rana Food Store
1623 West Arkansas Lane
Arlington, TX 76013

Phoenicia Bakery & Deli
2912 S. Lamar
Austin, TX 78704

Worldwide Foods
2203 Greenville Ave.
Dallas, TX 75206

Droubi's Bakery & Grocery
7333 Hillcroft
Houston, TX 77081

Jerusalem Bakery & Grocery
201 E. Main
Richardson, TX 75081

Virginia

Mediterranean Bakery
374 S. Picket St.
Alexandria, VA 22304

Halalco
108 E. Fairfax St.
Falls Church, VA 22046

Aphrodite Greek Imports
5886 Leesburg Pike
Falls Church, VA 22041